MEDIUM FORMAT PHOTOGRAPHY

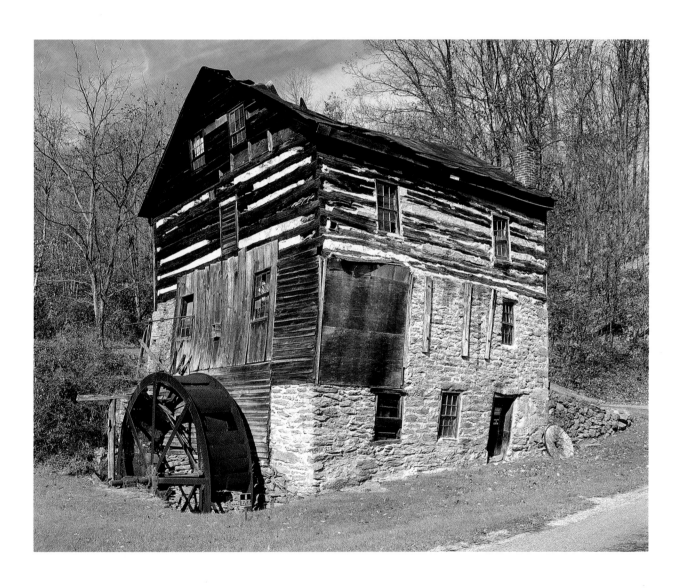

MEDIUM FORMAT PHOTOGRAPHY

LIEF ERICKSENN

AMPHOTO
AN IMPRINT OF WATSON-GUPTILL PUBLICATIONS/NEW YORK

The editors would like to acknowledge the following, without whose help this book would not have been possible:

Arlene Muzyka, Butch Hodgson, Prof. Thomas A. Richards, Paul Klingenstein, Jan Lederman, Joe Meehan, Lucille Khornak, Joni Note, John Hamilton, Bob Solomon, Roy McJunkin, Fuji, Rollei, Mamiya, and Bruce Weaver.

Photographs on pages 1, 2-3, and 6-7 by Butch Hodgson.

Copyright © 1991 by Arlene Muzyka

First published 1991 in New York by AMPHOTO, an imprint of Watson-Guptill Publications, a division of BPI Communications, Inc., 1515 Broadway, New York, NY 10036

Each of the photographs appearing in this book is copyrighted in the name of the individual photographer. All photographs not otherwise credited are copyrighted by the author.

Library of Congress Cataloging in Publication Data
Ericksenn, Lief.
 Medium format photography / Lief Ericksenn.
 p. cm.
 Includes index.
 ISBN 0-8174-4555-2 : — ISBN 0-8174-4556-0 (pbk.) :
 1. Medium format cameras. 2. Photography—Handbooks, manuals, etc. I. Title.
 TR257.E75 1991
 771.3′2—dc20 90-25843
 CIP

Manufactured in Singapore

1 2 3 4 5 6 7 8 9 10 / 96 95 94 93 92 91

THIS BOOK IS DEDICATED TO THE NASA SPACE SHUTTLE PROGRAM, HARRY RINGBILL, AND AN OLD SAMURAI.

Born in St. Anne's, Lancaster, England in 1935, Lief Ericksenn's photographic career began when a favorite aunt presented him with the gift of a camera. Self taught, he proceeded from photojournalist to teacher to still-photographer for the BBC, to major motion picture work. A fall from a stunt horse while photographing the BBC production of ''War and Peace'' precipitated events that brought him to the United States in the early 1970s.

Mr. Ericksenn's many professional credits include: Editor-In-Chief of *Photomethods,* Technical Director of *Peterson's Photographic,* as well as Editor-In-Chief of *Camera 35,* and two previous books for Amphoto.

The Third Eye, a series of essays that appeared in *Camera 35* and the more recent newsletter, *Angle of Incidence,* established Mr. Ericksenn as a man to whom photography was merely a means to view the universe and our place in it. He was a vocal and inspired ecologist long before it was fashionable, and he will be sorely missed by the wood ducks and the blue heron on the banks of the Musconetcong River.

—Arlene Muzyka

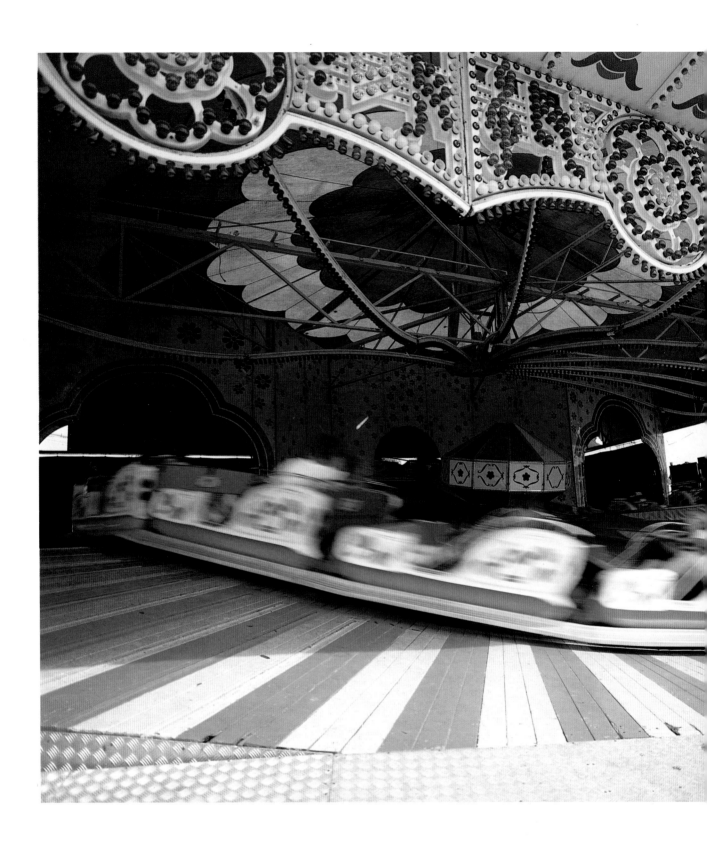

CONTENTS

INTRODUCTION

When Amphoto suggested I undertake this book, my response was, ''That's quite a tall order; medium format is a large field (if you'll forgive the pun) and others have had a heyday in it.'' On second thought, people depend on information, and information about photography is changing so rapidly that a lot of it is hard to understand and digest. So, I decided, why not tackle the subject of medium format? This book is designed to be a primer for anyone interested in medium-format cameras, lenses, accessories, and of course, techniques. It doesn't pretend to teach professional photographers their trade or tell them what they probably already know. I hope this book will interest a wide variety of photographers and will be an easy and enjoyable read for all.

Medium format is, by consensus, a rollfilm format larger than 35mm. It could be argued that medium format ends at 4 × 5 inch sheet film, but in fact, medium-format rollfilm cameras are actually only limited across their width. The maximum width is 6cm, but depending upon the ''gate'' of the camera, the length of the frame can be almost anything. For example, I have cameras in my equipment cabinet that shoot 6 × 4.5, 6 × 6, 6 × 7, 6 × 9, 6 × 12, and 6 × 17cm exposures. These all use the popular 120 or 220 rollfilms, or they have magazine backs that accept longer rolls of 70mm film. But with a panoramic or circuit camera, the length of the image can be even greater since such instruments scan the scene up to 360

degrees. These are rather esoteric instruments, usually not the camera of choice, but they are still medium format.

So if a camera uses paper-backed or paper-leadered 120 and 220 film, or the edge-perforated 70mm film stock, it is medium format. If it uses either 35mm or smaller, or 4 × 5 sheet film and larger, it is not. But even with the larger cameras, there is an exception. Most cut-film cameras 4 × 5 and larger are able to use a rollfilm holder, thus reducing the larger format to medium.

Both Graflex and Calumet produced 4 × 5 cameras with roll-film adapters for 120 film and a format of 6 × 7cm. Other large-format camera manufacturers marketed cameras that were 6 × 6 and 6 × 9, but many of the lenses used on cameras 4 × 5 and larger didn't have the resolving power found on any good medium-format camera built after 1970. However, most people consider medium format to range from 6 × 4.5 to 6 × 17cm, using either rollfilm or 70mm stock. Except for brief mention of the rather esoteric rotational picture-taking machines, I, too, will stay safely between the 6 × 4.5 and 6 × 17cm parameters.

Undoubtedly, the 35mm camera dominates the amateur and professional market, which is no surprise or mystery. The 35mm, especially the 35mm single-lens reflex (SLR), is probably the most highly developed system camera ever conceived. With lenses ranging from 16mm to several thousand millimeters, auto focusing, auto exposure, high-speed motor drives, and error-proof metering algorithms burnt into the heart of its on-board computer, it is virtually the camera for "every-man." Yet despite this, medium-format cameras survive, not by competing with 35mm's 24 × 36mm format, but by simply out-gunning it.

If the standard medium-format camera is 6 × 6cm (the true dimensions are actually 55 × 55mm or 2¼ × 2¼ inches square), it is evident that, as an SLR, it is twice as big as even the most loaded 35mm SLR. The lenses are also proportionately larger; working with medium-format telephoto lenses of the format, you begin to understand the meaning of equipment size and weight. Although a high-quality 1000mm catadioptric (mirror) lens for a 35mm system is about 10 inches long and weighs about 2 pounds, you can handhold such a camera and lens combination if you know what you're doing. The equivalent focal length for 6 × 6 would be at least three times as long, and about five times the weight. For example, the Zeiss Mirrortar F5.6 1000mm catadioptric lens designed for the Rolleiflex SL66 E and X weighs in at 36.4 lbs. The Zeiss Tele-Tessar F8 1000mm refracter (nonmirror) lens weighs 19.3 pounds. And such triumphs of modern lens technology are expensive.

Automation has come to the medium-format camera at a slower and more cautious pace than to the 35mm. Again, the reason is largely logistical because every-thing is larger. But where automation has been built into medium-format cameras, it has generally been done very well, especially in the area of built-in, coupled, and automatic exposure meter systems. Compared to 35mm, motor drives for medium-format are not very fast, but considering that they can advance film automatically from about 1.5 to 3 frames-per-second, they are not bad. A few special cameras can haul 70mm film through the gate quite fast, but they are not general-purpose machines.

Medium-format cameras aren't only confined to SLRs. Many rangefinder-type medium-format cameras are available, and if you don't need a wide array of inter-changable lenses, you might consider using the more compact rangefinder and noncoupled focusing rollfilm cameras. Some of these systems do have interchangable, or coupled, lenses, but for the most part they are limited to a range of focal lengths from about 50mm to 90 or 150mm. Such cameras are compact, often have a reliable built-in coupled exposure meter, weigh a lot less than their SLR cousins, and make fine general-purpose cameras. I shot several thousand rolls of 120 color reversal film on two such cameras while working for the BBC's productions of "War and Peace," "Lawrence of Arabia," and several others. They never faltered once, and I was never pressed for focal lengths (what you don't have, you don't pine for). There has also been a resurgence of what might be called medium-format

The advantages of the medium formats—ranging from 6 × 6 all the way to 6 × 17—over the smaller 35mm format is obvious at first glance. Not only is any medium-format image larger, and therefore more persuasive, but it also allows you to enlarge portions of the picture without loss of image quality. (Photographs by Butch Hodgson).

35MM

6 × 4.5

6 × 6

6 × 7

"briefcase" cameras. Sometimes folding, sometimes not, these machines have one permanently mounted lens coupled to a rangefinder body with an exposure meter. They are compact, quiet, and produce big, beautiful pictures.

Medium-format cameras, SLR or rangefinder, are just as easy to use as a versatile 35mm camera. Some medium-format cameras may look forbidding, but they aren't really. In some respects, a larger camera is actually easier to use; the controls are larger, the focusing screen is larger, and the camera's proportionately greater weight can work for you. But note that the overall cash investment for a medium-format system is greater than for 35mm equipment. Re-

member, too, that lenses are the heart and soul of a camera and that there is a lot more glass in a medium-format camera lens; thus, it tends to cost a lot more than one for a smaller format. Between-lens shutters are also quite expensive; however, the old saying "you get what you pay for" is evident in the image quality that medium-format lenses produce.

A BRIEF HISTORY OF MEDIUM FORMAT

I'm not big on history, believing that it largely ended when the pharaohs of Egypt vanished. But medium-format had to begin somewhere, so let's take a quick look into its origins. Some maintain that the Daguerreotype, way

back in the 1840s, was the sire of all medium-format images. Those early silver-on-copper plate pictures were generally scaled at 6½ × 8½ inches. They were, however, solid copper plates, not paper prints.

With the invention of flexible rollfilm—attributed to George Eastman but actually invented by a Newark, New Jersey cleric, Hannibal Goodwin—the medium-format became the popular picture maker (until the introduction of the 35mm camera in 1925). Around 1888, Eastman Kodak introduced a "box" camera that made 100 exposures on 2¾-inch-wide stripping film. Actually, the camera produced images that were 2½ inches in diameter and circular. "You

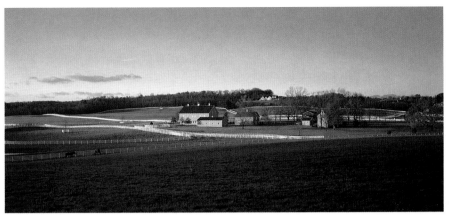

6 X 12

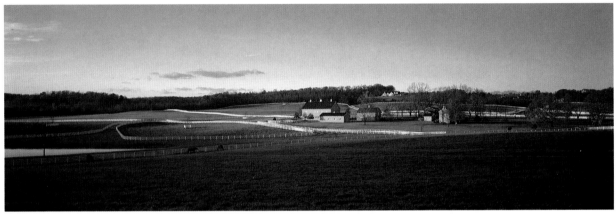

6 X 17

press the button, we do the rest," was the Kodak advertising slogan, since the entire camera was sent back to the factory to be processed and printed. As a footnote, it is interesting to observe that photography has come full circle; there are now inexpensive, pre-loaded cameras (although not medium format) that require you to return the entire camera to the manufacturer for processing. Disposable technology, you see, is not new.

Until about 1891 when the Kodak Daylight camera showed up on the scene, cameras generally had to be loaded in a darkroom. The Daylight camera introduced a crude form of cassette loading in which film inside a light-proof cardboard box was transferred to

another light-tight box within the camera as the user took pictures.

Even in those days, however, photography was not solely Kodak's domain. Around 1892, the Boston Camera Company developed the concept of rollfilm spooled together with black, light-tight backing paper. The paper, as with modern paper-backed or leadered rollfilm, fit tightly against the solid flanges of the spool and blocked out any light. This system has never really changed, proving the old saw, "if it ain't broke, don't fix it." In order to determine how far to wind the film for each exposure, the camera back had little red windows in it. You wound the film until the correct number, printed on the backing paper,

showed in the appropriate window. The old "Bulls Eye" camera brought a lot of people into photography by making the process of taking pictures fun and easy. Later on, the Boston Camera Company was bought by George Eastman and his company, and its techniques and patterns were incorporated and expanded for the Eastman Kodak cameras. One improvement was the removal of the numbers on the back of the film; instead, the camera automatically stopped for each new frame.

Around 1903, the Kodak Model 3A folding camera appeared, and the compact camera wars began. It was dubbed a "pocket camera" and employed a Bausch and Lomb F4 170mm lens. This camera also

introduced the ''iris diaphragm,'' a set of overlapping thin metal blades within the lens that control the amount of light entering the camera. It featured a waist-level viewfinder that could be rotated from a vertical to a horizontal position for best framing. The front lens panel was connected to the body via a bellows, and the standard lens slid along a pair of rails mounted on a flat bed that, when folded upwards, turned the camera into a flat, pocketable package. This camera spawned many variations, all precise instruments featuring high-tech lenses (for the time) and some sophisticated leaf-shutters with considerable ranges of speeds. Indeed, the modern leaf, or between-lens, shutter, is a direct descendant of many of those innovative folding cameras.

The most revolutionary medium-format camera has to have been the famous and much beloved Rolleiflex. Reinhold Heidecke's ''Rollei'' appeared on the scene in 1929. It was precise, innovative, and above all, quick and easy to use. The film advance was automated by adding a folding auto-stop crank, the lenses were excellent, and aiming was sure. The photographer saw a bright, upright image projected on the focusing screen by the viewing lens. It was mounted directly above the taking lens that projected the image onto the film. The whole lens panel was moved to focus the camera by means of the focusing knob, and the nature of the design eliminated vulnerable cloth or leather bellows. One could argue that the Rolleiflex twin-lens-reflex (TLR) was the most successful camera ever made. It has been used everywhere in the world, became the staple of the amateur and the professional photographer alike, and still exists today in a much developed form. Indeed, the Rolleiflex 2.8GX, with its sophisticated focusing screen system and accurate, built-in, coupled metering system (which is actually through-the-lens for both ambient light and flash work) is comparable with many of the modern medium-format SLRs of today. Other companies joined in the game. Zeiss and Voightlander, for exam-

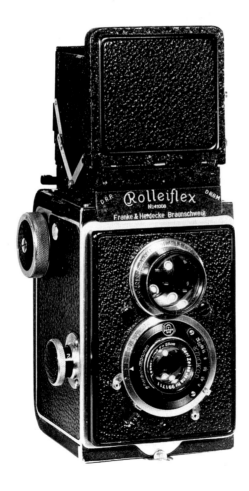 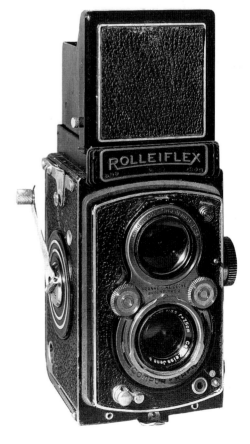

The camera on the near right is the original Rolleiflex twin-lens-reflex, manufactured in 1929. (Courtesy: Rollei.)

On the far right is the Rolleiflex Automat. Manufactured in 1937, it featured an F3.5 75mm taking lens and a Compur-Rapid shutter. (Courtesy: California Museum of Photography.)

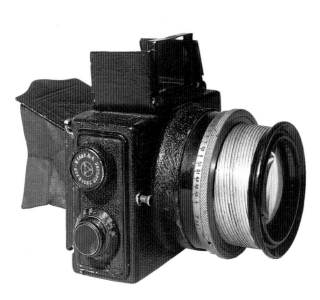

The 1924 Ermanox ''Ernox'' featured an F2 100mm lens and a focal-plane shutter. (Courtesy: California Museum of Photography.)

Hasselblad's 1600F (1948-52) was the world's first 6 × 6 camera with interchangeable film backs. (Courtesy: California Museum of Photography.)

ple, introduced smaller TLRs. But, Rollei, unperturbed, also developed a sort of ''mini-Rollei;'' using 127-size film, it shot a 40 × 40mm format image known familiarly as the ''superslide.''

Meanwhile, medium-format single-lens-reflex models were lurking in the wings. Actually, the SLR had been around for quite a while; there were a number of larger format SLR manufacturers, many of them using plates or cut film. Around the 1930s came the Vest Pocket Exacta that used 127 film; but in my opinion, it was probably the 120 Reflex Korelle that ushered in the modern medium-format SLR. The Reflex Korelle and the Exacta both featured interchangeble lenses. Lens changing was a bit slow because the mount was a screw type, but they were true interchangeable lens SLRs with rear-positioned focal-plane shutters. So well made were

these cameras that I remember many photographers still using them in Britain long after World War II when new equipment was hard to come by. The famous Ermanox camera, a small 4½ × 6cm camera, was introduced in the 1920s. It had a permanently mounted F1.8 lens, quite a fast lens for its day, and was a very famous and popular press camera. Specimens of it survived in general circulation well into the 1950s, and it was quite common in used-camera stores. This proves that fast lenses have been around for quite a while.

Folding cameras weren't neglected, either. Precise, coupled rangefinders and faster lenses were added to them, creating competent, professional tools. The speed of the focal-plane shutter for medium format was boosted to 1/1000 sec., setting the stage for the next revolutionary SLR, the

Hasselblad 1600F that appeared in 1948. A medium-format, interchangeable-lens, SLR camera that also featured precise, interchangeable, rollfilm backs, the ''Hassie'' soon skyrocketed into professional popularity despite its rather sensitive titanium-foil rear-curtain focal-plane shutter. It didn't take Hasselblad long to opt primarily for lens shutter systems after the 1600F. Even so, interchangeable film magazines are not new, just refined for today's standards.

Had enough of history? Probably. Some people may disagree with my assessment as to which cameras were pivotal in medium format's development. Even so, I think this chapter indicates that medium format cameras have a long and noble lineage. Even today they stand toe to toe with 35mm machines as the cameras of choice for professionals and serious amateurs alike.

WHAT MEDIUM FORMAT HAS TO OFFER

As modern medium-format SLR and TLR cameras have developed, they've shed the image of being slow, under-systemed, heavy, and difficult to use. All things considered, today's photographer has more to gain by going into medium format than ever before. The modern cameras are lighter, more versatile and agile, and perhaps most important, they produce large, psychologically persuasive images. The psychology of seeing is an intricate thing; it is as much subjective as it is objective, as proved by a simple experiment. On a light table, lay down a set of 35mm slides identical in color and image quality to another set of, say, 6×6cm slides, and ask some friends to look at them. Watch their reactions. Somehow, the old adage that, ''a good big 'un beats a good little 'un every time'' holds true. The area gain of the medium-format slide is 3.6 times that of 35mm; and the larger the format, the greater the impact.

Now try the same experiment using a slide projector. The sheer power of the 6×6 images on the screen generally subdues any argument. And if you did your job as a photographer right, you can increase the projection size of 6×6 slides to an enormous area with no lack of image sharpness. Larger formats offer even greater persuasive powers. Try a set of 'chromes (slides) shot with a 6×17 wide-field or panoramic camera. On a light table they look like parts of a huge stained glass window, and boy, do they sell.

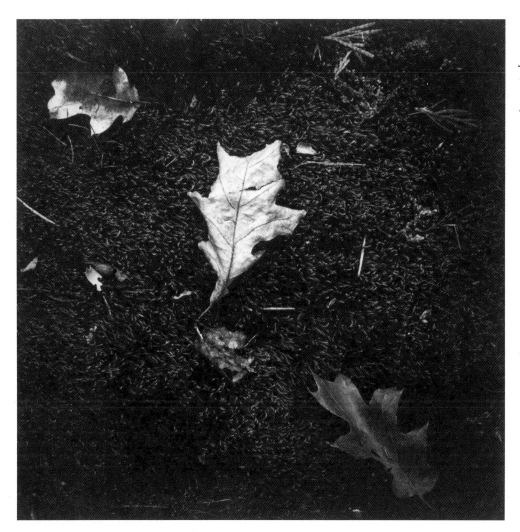

This black-and-white study was taken in the field with a Hasselblad ELM and an 80mm lens. (Photograph by John Chakeres.)

It is certainly easier to ''read'' a medium-format slide or negative; and anyone who has spent hours working over a light table sorting 35mm slides or preparing a slide show understands why bigger is definitely better. Of course, if you are shooting color negatives, you should probably have the lab make contact sheets when they develop the film. The bigger the format, the easier it is to evaluate images and mark them up for printing, cropping, and general manipulation. For 35mm contact sheets, you sometimes need to invest in enlarged-image contact sheets for easier viewing.

Another clear advantage of medium format is that the greater image size allows you to enlarge considerable portions out of the negative and still maintain total quality. Here is a rather sad, but telling example: On that fateful morning when the space shuttle Challenger broke up in the cold, clear air above the Kennedy Space Center, I was about 40 miles away at the Orlando airport. With all the delays by NASA, I had run out of time for that particular launch and had been forced to leave for other commitments. But I still had a bad feeling that they might try to launch on that inclement day (the

launch criteria are ''no-go'' at temperatures less than 50°F, and the temperature was well below that). I kept my Rolleiflex 6006 Mk2 6 × 6 SLR with a 250mm Tele-Sonnar lens with me as I waited for my flight. When I heard on the radio that they had started the final countdown, I walked onto the parking ramp and looked back in the direction of Cape Canaveral. Alas, Challenger came barreling up over the horizon and I began a series of paced, motor-driven shots. On about the sixth frame it exploded, and the rest, as they say, is history. Now the Rolleiflex 6006 is a superb camera, and the

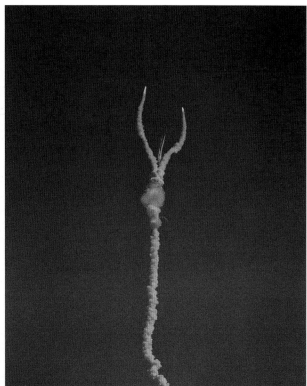
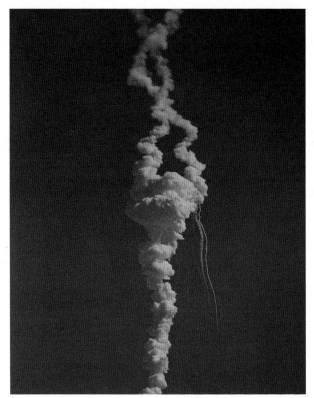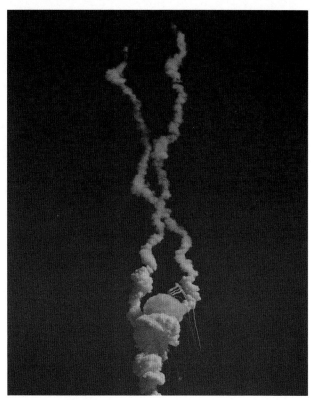

I shot these images of the space shuttle Challenger *disaster from 40 miles away at the Orlando airport. A 50 percent enlargement was made from a cropped area of the negative, which is a tribute to the quality of the Tessar lens, the capability of modern color emulsions, and a cogent argument for medium format.*

Tele Sonnar is a fine Zeiss lens but not very powerful when you consider the format and the distance involved. Still, the central strip of the negative was easily enlarged, and I was able to pull tack-sharp 11 × 14 inch prints from it; a tribute to the lens and camera technology, the film, and the format it employs.

MEDIUM FORMAT'S RISE IN POPULARITY

Why is medium format making inroads into 35mm photography, not only among professionals, but among amateurs as well? The cynical would say that it is partly to do with the fact that manufacturers have saturated the 35mm market and must seek other pastures in which to graze. The range of equipment has grown incredibly over the past few years, and today's photographer can find a medium-format camera to suit every price and every application, from folding pocketability to super-telephoto and super-macro capability.

But the growth in medium format is also due to the wide variety of image options. The medium-format camera is as at home in the field as it is in the studio. It is flexible and tractable for handheld work and offers creative opportunities without being confined to the cramping effect of a tripod. Most modern medium-format cameras are technologically innovative, too; one model features automatic metering for both ambient light and flash exposures, and its onboard computer controls almost

every mechanical function. Additionally, there are new approaches to shutter operations. The Rollei 6006 and 6008, for example, use linear-wound motors in each lens to drive the between-lens shutters; and with the advent of new lenses, shutter speeds can approach 1/750 sec. This alone rivals many focal-plane shutters for speed performance. Motor drives or add-on motor winders further automate and speed up the cycling time of the new medium-format machines. Special algorithms built into computer chips offer special metering effects such as automated bracketing for exposure. Medium-format cameras also come quite close to the dimensions of a full-size 35mm SLR. The Mamiya 645 and the Bronica ETR, for example, are quite compact. They use conventional 120 or 220 rollfilm, offer more frames per roll, and still provide a bigger negative than 35mm (4.5 × 6cm as opposed to 24 × 36mm). There is also a large array of fairly compact lenses for the 645 format.

Some medium-format cameras also offer rather technical innovations in the area of perspective-control (PC) lenses. There are several cameras in the medium-format line-up (both SLR and rangefinder types) that permit considerable lens movement across the film plane. While not all the lens movements are extreme, they do offer solutions to a lot of photographic problems in the field. There are many PC lenses for 35mm cameras, but their utility is limited. Offering this type of lens for 35mm has always seemed a bit incongruous to me; no camera can do everything.

When asked why they use medium format, most photographers point to the convenience of working with an interchangeable film back; it is like having several cameras in one. Pre-loaded film backs permit a photographer to mount another as soon as the first one runs out without breaking his or her shooting stride. And if while on assignment the photographer has to shoot more than one type of

Here you see the Rollei 120 film back being loaded and then fitted onto the Rollei 6006 SLR camera. (Courtesy: Rollei.)

film, another back can simply be fitted to the camera. There is even no need to finish the roll; film backs can actually be changed in mid-roll. For example, if you are working with a slow film, say ISO 100, and the light suddenly fails on you, you can immediately switch to a faster film. If you wish to use an auto-winder, a film back containing a longer roll of 70mm film will allow more exposures. A Polaroid back and a sheet-film back are available for special applications. The Polaroid instant-film back has saved many reputations by allowing photographers to shoot test pictures and then immediately evaluate them. Of course, there are Polaroid backs for 35mm SLRs too, but none offer the same speed of interchangeability as the medium-format camera.

So where do the advantages of using a medium-format camera come into play? In practically all photographic endeavors except where larger pieces of film are required or full camera movement is needed. The 6 × 6cm SLR is useful everywhere from the portrait studio to the wedding ceremony. It is excellent for wide-angle to telephoto work and can be modified for doing scientific photography. For example, it is at home mounted on a microscope, working with a macro lens or bellows, and on the end of an astronomical telescope. In fact, medium format has been involved in the space program ever since Wally Shirra insisted on taking his personal Hasselblad with him into orbit. It is now included on every space

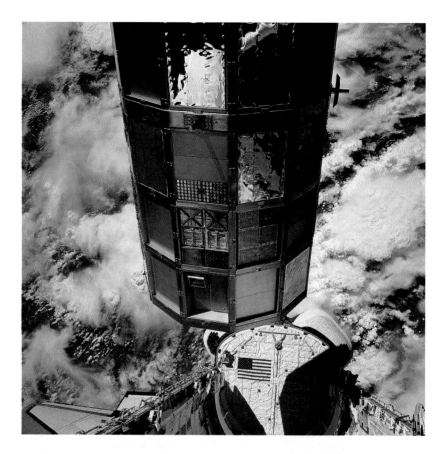

The recovery of the Long Exposure Duration Facility satellite by the space shuttle offered an excellent photo opportunity to the astronauts, who made this series of photographs with a Hasselblad ELX and a 150mm lens. (Courtesy: NASA/Hasselblad.)

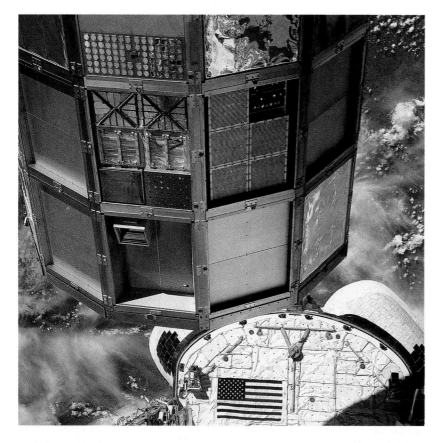

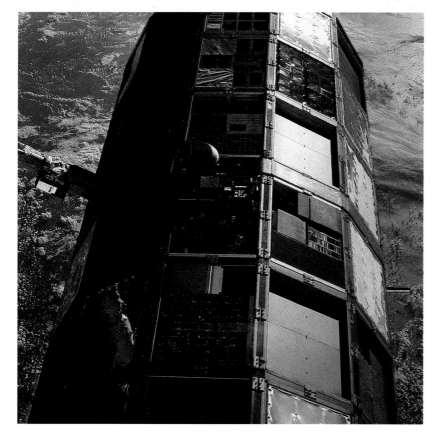

shuttle mission, and widely used by shuttle photographers on the ground as a remote operated camera. The medium-format camera is employed in all areas of quality photography and will undoubtedly be so until the day when film is finally obsolete.

CHOOSING A FORMAT

If you are contemplating buying a medium-format camera or system, the first thing you'll learn is that everyone has an opinion on which is the best model. Remember, what you buy and why you buy it is entirely up to you and your needs. Moving into medium format can be quite expensive, so carefully consider the different aspects of the format before you jump into anything. As stated earlier, the width of the medium-format camera's frame is constant, but the length of the image is not. Certainly the most "famous" image size is 2¼ × 2¼ inches or 6 × 6cm. This format dominated the medium-format camera right up until the 1960's when other image sizes began to appear.

But why would you want a square format? The human eye certainly doesn't see in a square format; in fact, the closest format to the human vision would be 6 × 12 or 6 × 17cm, the logical "letter box" shape. Well, it has a lot to do with early camera design. Imagine if the early Rolleiflex TLR had been designed around a rectangular (horizontal) format. Assuming that the shape was configured for landscape, the benefit of the format's increased dimen-

sions would be irrevelant if you shot portraits because you'd probably have to crop off so much of the frame. And turning the camera on its side to accommodate the vertical use of the rectangular format doesn't work. Just try looking into a waist-level finder with the camera tipped sideways; the attempt is awkward and disorienting. So the square format was originally quite logical. You might still have to crop the image, but you lose less film that way than when using a rigid-back rectangular format. Besides, the square has an aesthetic of its own, which, once learned, works fine.

With the introduction of the revolving film back, the question of format shape becomes academic. After all, to switch from landscape to portrait mode (that is horizontal to vertical), simply revolve the back 90 degrees, and a mask in the viewfinder accommodates the new orientation. Revolving film backs

I shot this image with the unique Fuji GX680 SLR camera on Fuji-chrome 400. Six-by-eight is an interesting format because it readily fits most printing paper sizes.

come with slightly larger format dimensions, usually 6 × 7 and 6 × 9cm. A typical example of a camera utilizing a 6 × 7 format and a revolving back is the Mamiya RZ67. The rotating back maintains mechanical and electrical coupling with the camera body in either of the two working positions.

There are also 6 × 7 SLR's designed to be handled like huge 35mm cameras. They eschew the traditional waist-level formula of Rolleiflex, Hasselblad, Bronica, and Fuji GX, and have evolved into what may be called supersized 35mm-style cameras. The fixed pentaprism permits the whole camera to be oriented horizontally or vertically, which does away with the need for rotating film backs. These cameras afford the quality of medium format with small-format camera handling. Between the 6 × 7 and 6 × 9 formats in the SLR line-up is a slightly strange format, the 6 × 8. This is Fuji's idea of the "ideal" format; their argument is that the 6 × 8 frame fits all conventional photographic papers. In fact, 6 × 7 and 6 × 4.5cm negatives fit the standard 4 × 5 or 8 × 10-inch paper most closely without cropping.

Where the format is smaller than 6 × 6—for example, 6 × 4.5—and doesn't include a revolving back, the image will usually be vertically oriented on the film. However, most cameras using the 6 × 4.5 format are compact enough to be easily turned on their side, permitting a landscape format. One of the main reasons for vertically orienting the frame is obvious; more frames can fit on a standard length roll of film. If it were oriented horizontally, there would be lot of unused film above and below the actual frame.

The preceeding descriptions cover almost all of the rollfilm formats available. While most of these descriptions are based on twin- and single-lens-reflex cameras, you should also be aware that these same formats are also available in the nonreflex, or rangefinder, models. Indeed, many of these nonreflex formats are available because it becomes quite feasible to extend the length of the frame. For handheld cameras the upper limit is about 6 × 17cm, a massively beautiful panoramic format that exploits the human eye's love of wide perspectives. Need even more length? Consider shooting with a scanning panoramic camera; its frame length is measured in hundreds of millimeters, and it is capable of shooting a 360 degree image.

SELECTING A MEDIUM-FORMAT SYSTEM

A lot has been written about which medium-format camera is best or which system to buy. Basically it all comes down to two factors; what you can afford, and what you intend to do photographically. Personally, I've been working with medium format for 25 years, and my photography assignments have changed quite a bit. In my early days as a newspaper stringer, my equipment requirements were simple and basic; during my years as a still photographer for motion-picture studios, the equipment was equally basic because of the amount of travel involved. When my shooting took a more specific and technical bent, the requirements for my cameras and lenses became more involved. But, I've always had an extreme distaste for traveling heavy; I only pack the big airline shipping cases when I absolutely must.

What follows is by no means a list of every medium-format camera available; that is included as a chart in the appendix. Much of my photography has been done with various rollfilm cameras; another part of my career has been to test different types of film and cameras. The following examples of equipment are designed to give the would-be owner some insights into the utility and application of various formats and types of cameras—from my point of view. You, of course, are at liberty to invent your own applications.

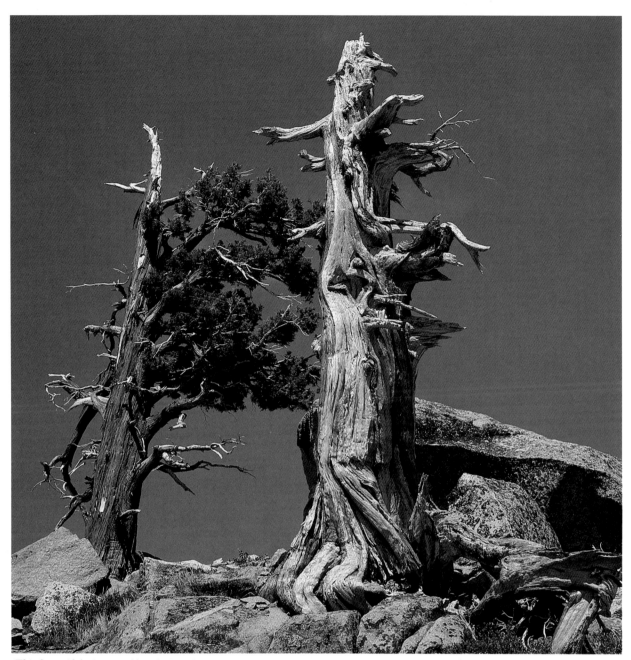

This beautiful picture of lonely Bristlecone pines was shot with a Hasselblad camera and a 120mm lens. A polarizing filter was used to emphasize the sky and increase the color saturation. (Photograph by Ernst Wildi, Hasselblad.)

TWIN-LENS REFLEX: THE CLASSIC

Back in the 1950s, press cameras were classically large-format folding types—such as the Speed Graphic—with a huge bulb-firing flash gun mounted on the side. The movie stereotype of the press photographer armed with one of these cameras and dressed in a trench coat wasn't too far off the mark. In those days, however, a format prejudice dictated that 4 × 5 was the only way to go, an attitude generated by the newspaper darkrooms. Dipping and dunking a sheet of film to develop it was a quick if sloppy procedure; no time for niceties when the press was waiting. Even so, I bought a classic twin-lens-reflex camera, a Rolleiflex 2.8F, equipped with the famous Zeiss Planar lens.

In the "good old days" of press photography, the Rolleiflex TLR was the standard camera used—you can see three of them in this picture. (Courtesy: Rollei.)

Despite some of the prejudices among press photographers, TLRs were increasing in popularity for three reasons: they were quick, sure to focus, and very quiet. Another strong point was that they were self-contained systems. As Rollei pointed out: "Our camera and a roll of film, and you are in business." This was, and still is, absolutely true. One problem with the early Rolleis was that you were confined by a single focal-length lens. Eventually Rollei offered two bayonet-on converter lenses that increased or decreased the focal length slightly. These were the telephoto (1.4x) and wide-angle Mutars. They didn't give you much telephoto power, and they didn't give you much wide-angle power, but they helped a little. In 1959, Rollei also produced the so-called Tele Rollei, a 6 × 6cm TLR with a 135mm lens system, and in 1961 they produced the wide-angle Rollei with a 55mm lens. Originally, because there was largely no decision about which lens to use, you could only exploit what you had. As a colleague of mine once remarked, "the best accessory a photographer has is his own two feet."

The Rollei TLR numbered many famous photographers amongst its devotees and was at home in war zones as well as portrait studios. The techniques that they developed for shooting with TLRs have persisted over the years. For example, if you couldn't see over a crowd, you simply held the camera inverted overhead at arms length. Looking up, you could still focus and aim it by looking at the focusing screen. Similarly, if it was safer to poke the camera around a corner rather than risking your neck, you operated it sideways. If there was ever a virtue to the 6 × 6 format, it manifest itself under such circumstances. And when compared to an SLR camera, a TLR has the advantage of its quiet operation. Because there is no mirror to slip out of the way, there is no loud "clunk," and no image blackout. Today, the Rolleiflex TLR flourishes in the even more advanced 2.8GX model, with a sophisticated metering system and a focusing screen that automatically moves to prevent parallax error.

Overcoming TLR Limitations.
Although Rollei tried to accommodate TLR photographers who

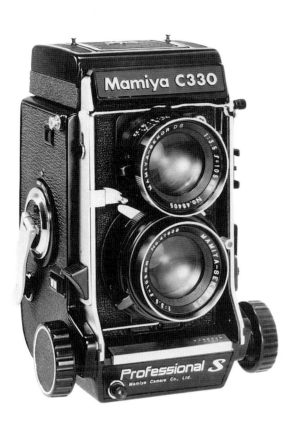

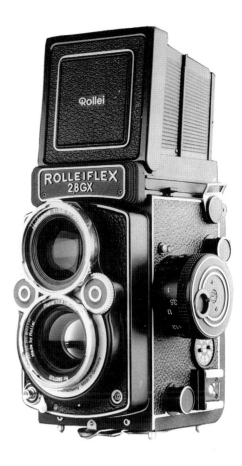

The Mamiya C330 differs from the Rolleiflex in that the Mamiya's lens panel is removable, allowing seven sets of lenses to be mounted. (Courtesy: Mamiya.)

The new Rolleiflex 2.8GX features an F2.8 80mm taking lens and TTVL metering. (Courtesy: Rollei.)

wanted alternative focal lengths by producing the wide-angle and telephoto cameras, they still had to carry three separate cameras to get three focal lengths. Mamiya saw its opportunity and in the late 1960s introduced the camera that undoubtedly put the company on the map, the Mamiya C-series TLRs. One of the main assets of the Mamiya C-series cameras is that they allow interchangeable lenses. The entire front lens panel unlatches and lifts out, including the viewing and taking lens/shutter combination. The essential configuration of the camera is classic TLR; however, focusing is by a long-throw bellows and rack-and-pinion system, which accommo-

dates a fairly large array of interchangeable lenses from a F4.5 55mm wide-angle to a F6.3 250mm telephoto. Additionally, the increased focusing travel with the bellows lets you take large, closeup images without recourse to special lenses. The rack-and-pinion system can be locked at any point. I bought one of the first Mamiya C-series TLRs with two or three lenses, and the system did sterling service. The lenses were as sharp as needles, and like the Rollei TLR, the camera was quiet by virtue of its lens/shutter system.

The current top-of-the-line Mamiya TLR is the C-330 with seven lenses at its disposal, ranging from the 55mm wide-angle to the

250mm telephoto. It still may be used handheld—perhaps a little more awkwardly than the Rollei due to the long focusing extensions—and is appropriate for almost any application. While 250mm is not a great deal of telephoto when shooting into a 6 × 6 frame, the Mamiya system delivers such quality that you can enlarge portions of the image quite considerably to boost your telephoto effect. The system has a host of accessories, such as 90-degree prisms and multiple viewfinder masks, and the Mamiya C-330 is absolutely at home attached to flash units ranging from bracket-mounted portables to the largest studio models.

ROLLEIFLEX 2.8GX EDITION

Scratch any long-time professional photographer and you'll find someone who probably learned how to shoot on a Rolleiflex TLR. Those who kept their old photographic workhorses may have been tagged as sentimentalists or collectors, and those who sold them are, like myself, still kicking themselves. Why? You can always dig a Rollei out of the closet, stick in a roll of film, and it works. The New Rolleiflex 2.8GX is an anniversary-edition camera covered in a special dark green nappa leather with a gold nameplate. The metal of the camera is finished in what I would describe as a sort of reddish, platinum color. It is a very handsome machine, comes in a special box, and is packed with a set of Rolleinar 1 closeup lenses, a neck strap, and a special edition of the "Rollei Collectors Guide."

This camera is a perfectly usable professional workhorse, for it is just the old 2.8GX in a new set of clothes. Ignore its finery and concentrate on it as the latest in the line of Rollei TLRs. There is a certain appeal, almost relief, to shooting with a fixed focal-length camera, because you have to "work with what you've got." Here you get to work with an Planar F2.8 80mm taking lens with a between-lens Synchro-Compur shutter, apertures ranging from f/2.8 to f/22, and shutter speeds from 1/500 to 1 second and "B." Focusing, for those who are too young to have owned a Rollei, is through the Heidosmat F2.8

80mm viewing lens mounted above the taking lens. Parallax compensation is automatic, and the camera fires with Rollei's traditionally quiet "tock."

THE BUILT-IN EXPOSURE METER

If you remove the folding focusing hood and the focusing screen, you can see how Rollei turned the 2.8GX into a TTVL (through-the-viewing-lens) coupled metering camera. A louver-shaped baffle with two Si photocells is concealed behind the TLR mirror. As the light is reflected from the focusing lens to the focusing screen,

a portion of that light passes directly through the mirror to impinge on the meter cells. The meter is heavily center-weighted, and the louvered baffles prevent stray light coming down from the focusing hood and screen and distorting the accuracy of the readings. The meter is powered by a PX28L, 6V battery that is housed in the focusing knob.

The meter readings are displayed at the top of the viewfinder in an array of five, colored LED indicators. The two outermost are red, indicating under or overexposure; the innermost are orange and define a half-stop deviation. The

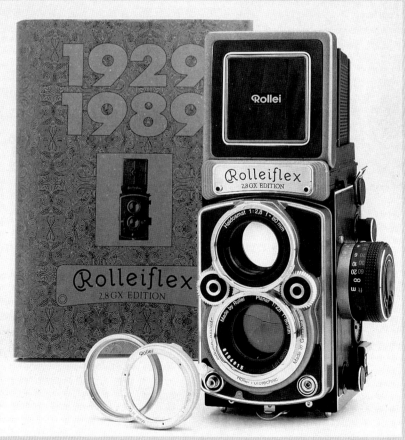

The New Rolleiflex 2.8GX anniversary-edition camera comes with a special edition of the "Rollei Collector's Guide." (Courtesy: Rollei.)

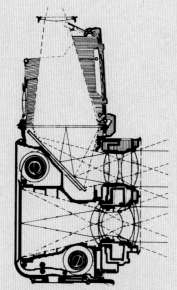

A cross-view of the Rolleiflex TLR shows how its two lenses work. (Courtesy: Rollei.)

center one is green and indicates the correct exposure. The camera accepts film speeds from ISO 15 to ISO 6400, a very workmanlike range. The film-speed setting is on a small dial adjacent to the dedicated-flash hot shoe. The exposure meter is ganged to the classic shutter-speed and lens-aperture wheels on the front panel. Although the readings might appear somewhat spartan when judged against the displays seen in many cameras, they nevertheless do the job, and the meter itself is quite excellent.

FLASH METERING
Flash metering with the 2.8GX is performed off-the-film-plane (OTF). A single meter cell is located in the bottom left of the camera chamber and looks back at an angle to the film surface. The system is the European SCA system and requires the appropriate SCA

356 adaptor to interface the flash unit and the camera's electronics. If you connect anything other than an SCA unit to the camera, the automatic through-the-lens (TTL) metering system is disabled. However, you are at liberty to connect any flash system you choose with the PC socket. For years I've owned two Osram "studio" flash units, the compact VS300 and the handle type S-440. They are both potent units with flash heads that rotate for bounce work. They couple to the Rollei via the SCA 356 adaptor. When the adaptor is acting as a mounting bracket, the clearance between the flash unit's body and the focusing knob is tight. Other units, including Osram's big SP-440 "potato masher" and Metz units, stand farther away from the camera using conventional mounting bracket. When using bounce flash with smaller units, switch to focusing with your left eye or risk being in the way of the flash beam when the reflector is aimed straight up. Of course, one of the nice things about TLR cameras is that you can actually see the flash fire through your focusing screen. But when looking for flash confirmation signals, always refer to the back of the flash unit.

FILM-TRANSPORT SYSTEM
The film-transport crank is combined with the shutter tensioning system, and the advance mechanism will automatically stop when the film is spooled up to the first

frame. An interlock prevents accidental double exposure; however, should you wish to do this deliberately, there is a knurled area on the fold-down crank's spindle boss that allows you to shoot and cock without advancing to the next frame. Some photographers have been a bit disgruntled by the fact that Rollei has done away with the film-thickness sensing rollers that used to automatically set the counter to "1." This discontinuance is due to the de-standardization of film and paper thicknesses. Instead, the arrow on the backing paper and the datum mark inside the film chamber have to be aligned before closing the back. One strong drawback is that the camera has no 220 film capability. This longer length rollfilm has its problems, but in a camera like the Rolleiflex 2.8GX, still popular with photojournalists and wedding photographers, the double amount of frames available with 220 film is sometimes an advantage.

THE FOCUSING SYSTEM
While the elegant simplicity of the 2.8GX focusing system has scarcely changed since the original Rolleiflex back in 1929, it has been improved and refined. It now has automatic parallax compensation, five interchangeable focusing screens, and both 45 and 90-degree prism viewfinders. Rollei fanatics, note that the entire screen now moves for parallax compensation, whereas, on all prior models, only the mask beneath it did.

MEDIUM-FORMAT SLR

In order to use a wider variety of lenses beyond the capabilities of a TLR or rangefinder camera, the SLR system is an obvious solution. With TTL viewing, almost any optic may be attached to the camera and directly focused with no limitations from accuracy or parallax. Also, because of the comparative size of a 6 × 6 SLR, the camera can be made to do things opto-mechanically that smaller formats find impossible or at least difficult. For example, in the area of camera movements, the medium-format SLR offers a surprising amount of flexibility exploiting the Scheimpflug effect, named after the geodetic surveyor Theodore Scheimpflug. His principle states that if the planes of the film, lens, and subject can be made to converge, the resultant image will be sharp overall (see page 68). So, a good number of the medium-format SLRs do have some ability to tilt and swing the lens by using bellows. There are also a number of perspective-control (PC) lenses available that can shift vertically or horizontally to accommodate such tricky subjects as tall buildings.

When an SLR has a focal-plane shutter, it is possible to mount virtually any lens on the camera. Basically, it doesn't matter if the lens operates in a fully automatic mode with the camera, because it will work to a sufficient degree to be useful. While some cameras feature aperture automation—that is, the lens is at its widest open aperture for focusing, and closes down to a predetermined aperture when

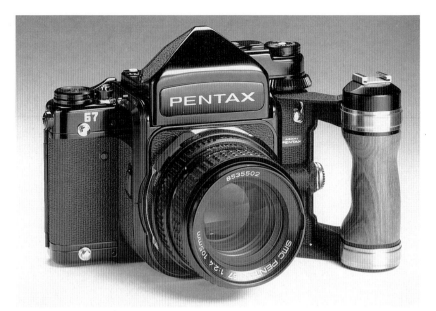

The Pentax 67 is a 6 × 7cm format camera that is designed to handle much like its smaller, 35mm counterparts, although it is substantially larger. (Courtesy: Pentax.)

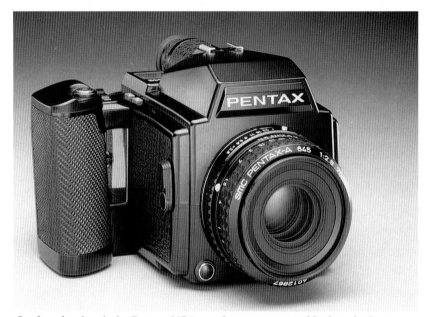

On the other hand, the Pentax 645 is much more manageable than the Pentax 67 and still produces negatives or transparencies larger than 35mm. (Courtesy: Pentax.)

you release the shutter—nevertheless, this action can be performed manually. There are a number of reasons for not employing the automatic aperture: using special lenses that lack coupling; reversing existing lenses for better macro or close-up corrections; using older, specially made, or even odd-ball lenses that may be adaptations from other systems; or attaching the camera to such devices as a microscope or an astronomical telescope. Just to complicate things, remember that a lot of special items, such as reversing rings and teleconverters, do permit automatic aperture operation.

There are two basic shapes to medium-format cameras: the boxy styles of the SLR and TLR cameras, and the slimmer, more rectangular shapes used for the nonreflex, rangefinder cameras. In most cases, function definitely dictates form. The boxy shape is necessary to accommodate the more complicated (and bulkier) reflex-mirror system of the SLR. If the camera is a nonreflex, rangefinder type, it is mechanically simpler and can be correspondingly thinner in profile. There always has to be an exception to the rule, and the Pentax 67 is one of those exceptions. Designed as an eye-level camera, the Pentax is shaped and styled to handle like a big 35mm camera with a 6 × 7 format. The pentaprism hump on the camera's top plate is a dead giveaway that it is an SLR. Pentax also

carries the 645, a smaller and more automated system using the 6 × 4.5 format.

As both cameras indicate, not all SLR medium-format cameras have to be in the 6 × 6 format. SLRs can range from 6 × 4.5 to 6 × 6, 6 × 7, 6 × 8, and 6 × 9cm. One of the most elegant in the classic SLR design using 6 × 7 is undoubtedly the Bronica GS-1. If the Bronica GS-1 has any limitations, they are that Bronica designed their own TTL/OTF automatic flash metering system instead of adopting a common industrial standard. This means that for proper TTL/OTF automation you must use a Bronica flash unit. Of course, the GS-1 works fine with other flash systems provided that you use either a flash meter or an external self-sensing unit that doesn't engage the cameras meter.

The medium-format SLR is a convenient solution to many problems. It offers the photographer handheld convenience, and it is equally at home in a studio or in the hands of a photojournalist. The hinged mirror is set at 45 degrees to the film plane and light coming in through the lens is reflected up onto a ground-glass focusing screen. The distance from the lens to the screen and from the lens to the film is exactly the same. When the photographer presses the shutter release, the spring or motor-driven mirror rises, allowing the light to hit the screen, and the shutter trips. After the shutter comes to rest, the mirror returns to its viewing position, and the film is advanced. Where the operation of the camera is manual, the mirror may be cranked down by advancing the film to the next frame.

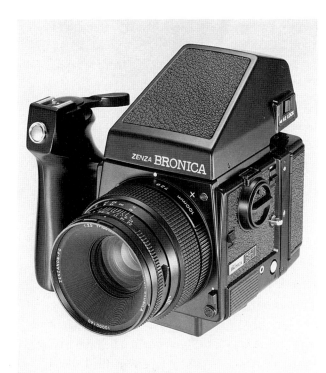

The Bronica GS-1 (with speed grip), a 6 × 7 camera, was designed to compete with the Mamiya RZ67. (Courtesy: Bronica.)

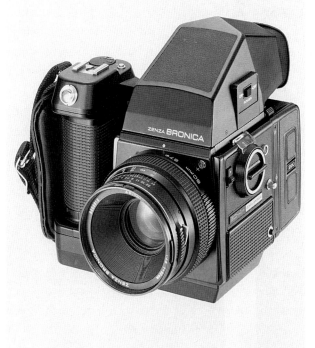

The Bronica SQ-Am is shown with an F2.8 80mm lens. (Courtesy: Bronica.)

Shutters. There are two basic approaches to shutters in medium-format SLR cameras. A focal-plane shutter is located directly in front of the film plane, while a be-tween-lens shutter, also known as a leaf shutter, is located between the lens elements themselves. For the most part, focal shutters have had the speed advantage, reaching 1/1000 sec. This advantage is de-creasing, however, because Rollei-flex recently introduced the 6008 model with a leaf-shutter system approaching 1/1000 sec. top speed. But the Rollei is unique be-cause its shutters are driven by very fast accelerating linear mo-tors. The classic leaf-shutter sys-tems use spring-driven shutters.

Although the focal-plane shutter does sterling service in nearly all aspects of photography, it is not the best shutter for high-speed flash synchronization. Generally speaking, the top flash synchroniz-ation speed is around 1/60 sec., maybe 1/125 sec. This is good enough for general situations, but where more control of the flash synchronization is needed, then the between-lens shutter has the defi-nite advantage. Classically me-chanical, it can synchronize for electronic flash at all speeds. Thus, it was no accident that Hasselblad, soon after bringing out the 1600F focal-plane "Hassie," quickly in-troduced the Hasselblad 500 C se-ries with a leaf-shutter system. This gave photographers an enor-mous advantage because the ratio of flash-to-ambient-lighting expo-sures could be accurately con-trolled by varying the shutter speed (see page 111).

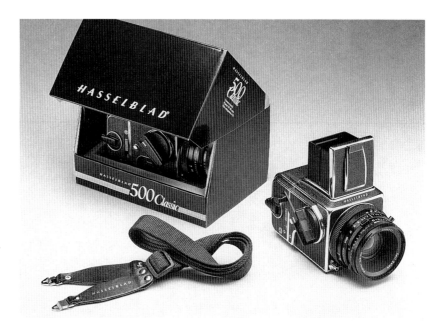

The Hasselblad 500C is sold with an F2.8 80mm Planar CF lens. (Courtesy: Hasselblad.)

So which system to choose, be-tween-lens shutter or focal-plane? If you intend to do a lot of studio flash work, then you'll require the advantages of a between-lens shut-ter. If your work is out in the field or just general photography, you might be best off with a focal-plane shutter. There are allegedly other advantages to between-lens shutters—supposedly they don't distort moving objects and are less sensitive to gravity—but frankly I don't accept these arguments be-cause situations where they can be proved are rare.

One of my first medium-format SLRs was a battle-scarred Hassel-blad 1600F with a shutter that bore the marks of accidental jabs from the edge of a film magazine being mounted while the previous owner ran for cover in a fire-fight. But despite its battered appearance and its reputation for a tender shutter, it never failed me. For it I acquired the strangest selection of lenses made from military surplus and

elsewhere. Many of these lenses were heavy, had no automatic dia-phragms, and were slow to focus by virtue (or lack thereof) of a long-throw focusing helix. But— and this proves the advantage of a focal-plane shutter—they could all be made to work. In fact, when I traded the Hasselblad, I kept the lenses and had them remounted for an early Zenza Bronica.

For me the move to a between-lens shutter system was not so much a technical necessity as it was pragmatic. The introduction of the Hasselblad ELM (now evolved to the 553 ELX), with its permanently built-in electric motor drive, also conferred the advantage of having both shutter systems. Having two shutters permits the use of lenses with or without shut-ters. If you find a particular lens that you like but it was designed without a between-lens shutter, you can have it fitted with a Has-selblad mount and use it with the focal-plane shutter.

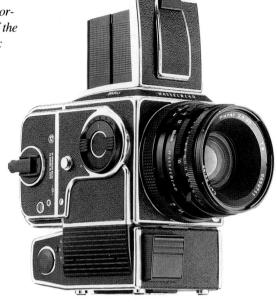

The Hasselblad 553ELX is a motor-driven version of the 500C. (Courtesy: Hasselblad.)

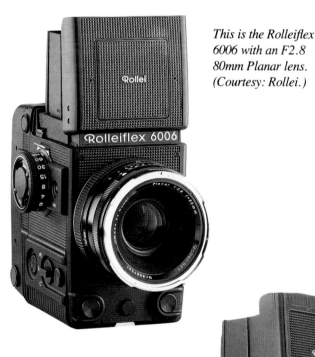

This is the Rolleiflex 6006 with an F2.8 80mm Planar lens. (Courtesy: Rollei.)

The new Rolleiflex 6008 is shown with the same lens. (Courtesy: Rollei.)

In order to marry the benefits of having both focal-plane and between-lens shutters, Hasselblad also introduced the 2003 FCW camera. This model has such refinements as a titanium focal-plane shutter with a top speed of 1/2000 second, a compact add-on electrical winder (able to cycle at about 1.3 frames per second, the standard medium-format rate), and the ability to use the standard Hasselblad CF lenses with built-in leaf shutters along with the new F-series lenses. The latter have no leaf shutters and are designed instead for use with the focal-plane shutter. But the dual capability of the camera expands the range of usable Hasselblad lenses to a current total of around 20, plus teleconverters and all the other imaging accessories.

Professional requirements tend to change over the years, and so photographers have to adapt equipment to match. When the Rolleiflex 6006 came along, it offered quite a number of advantages, specifically in the quality of the lenses and the built-in conveniences of camera function. The versatile Model 6006 Mk2 followed, and then the Model 6008 with its fast lenses and quick shutters. Model 6006 Mk2s are the cameras I primarily use in remote systems for all my space-shuttle photography down at NASA's Kennedy Space Center. Some argue that battery-driven systems are dangerous because if the power goes, so does the camera. I think this is an unfounded argument; electronically driven cameras are extremely reliable nowadays.

THE MAMIYA RZ67 PROFESSIONAL

The RZ67 evolved from the very successful RB67, 6 × 7 format SLR and is undoubtedly one of the big-gun choices of the professional. While the two cameras are still much the same, the RZ67 has some mechanical and electronic improvements for easier handling. By integrating the film-advance and shutter-cocking functions (the RB67 has separate levers for each) the RZ67 Professional is able to utilize an optional auto-winder. As winders go it is no scorcher, but it is adequate. Although the camera does have some electronic controls over functions, it isn't picky and responds to direct commands. If I make much of this, it is because I do a lot of remote camera work. In fact, some of my remote work is of the "set it and forget it" type, "hoping" that the camera will come to life under the command of a remote sound trigger. Sophistication in cameras is often best expressed in their simplicity and reliability in operation. The Mamiya RZ67 has such sophistication in spades.

The Mamiya RZ67's revolving back makes switching from a horizontal to a vertical format quite easy. (Courtesy: Mamiya.)

This exploded view of the Mamiya RZ67 reveals the simple elegance of its design, engineered to make its components easily interchangeable. (Courtesy: Mamiya.)

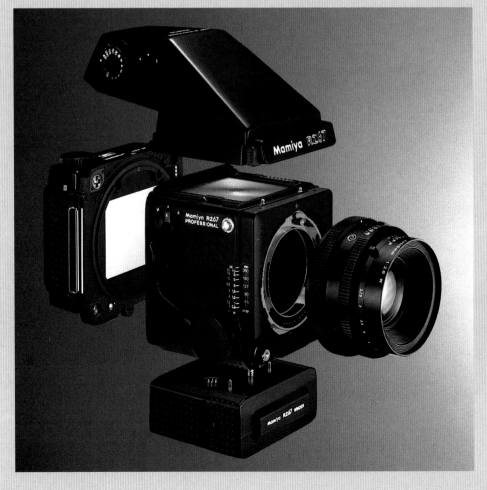

THE SYSTEM

Naturally, any camera is only as good as the system that supports it. To the professional, the system infrastructure is where the choice is made after all the technical specifications of the primary equipment (the camera) have been examined. This system is certainly not short on optics. It has 18 lenses, ranging from a F4.5 37mm "fish-eye" right through to a F8 500mm (with a F4.5 75mm shift-lens and a F4.5 140mm macro lens in between), plus a 100–200mm zoom and four apochromatic (APO) lenses. There are four viewfinders: the standard pop-up hood that is supplied with the camera, the eye-level PD prism finder, the AE metering prism finder, and the AE magnifying hood. There are seven focusing screens and five basic film backs (120, 220, 120 6 × 4.5, 120/220 6 × 6, and a Polaroid back). The G adaptor also permits the use of RB backs on the RZ. Then there are the usual additional accessories such as camera grips, eye-piece diopters, cables, cases, the RZ67 power winder, and of course, the radio remote-control set for field work.

In a way, the design and finish of the Mamiya RZ67 is rather spartan. It is perhaps one of the most functional cameras you may come across. Despite its mass— 5 pounds, 8 ounces (2.4 kg) with a F2.8 110mm lens—it is well balanced, and the major control placements are excellent. Most of the contact surfaces on the body are covered with a rubberized material that affords pleasant tactility and a firm grip. The controls are large and easy to locate without the photographer having to continually look down to find them.

OPERATING THE MAMIYA RZ67

Working with the camera is delightful. Despite the fact that it is obviously a bulky unit, it is surprisingly agile and well balanced. The controls are primarily right-handed, and it is easy to keep your finger on the shutter release while focusing. The left hand is free for operating the shutter speed dial or the lens aperture ring as needed. The rack-and-pinion focus may be operated from either side, and the left side has a locking lever. This is especially useful in remote operation where the camera is set up and left untended. Sequential shooting and exposure bracketing is a snap, providing you have the winder fitted to the camera's base plate. Handheld shooting is difficult but possible, even with the F8 500mm telephoto lens mounted. In fact, the camera's mass actually works for you by damping out any tendencies to jerk when the shutter is released. The RZ67 is surprising in its simplicity of operation, no mean feat for a camera of its size. The rotating film back adds to the pleasure of operating the camera by permitting instant switches in frame orientation. The viewfinder automatically masks the frame in either the horizontal or vertical position to match the back position.

Loading film into the RZ's back is simple and straightforward. Film threading is the reversed-curl type just like on most other cameras. Inch the film in with the magazine knob, lock the back, and either manually advance the film via the lever wind until the counter stops at #1, or depress the "stat" button on the winder and the camera will automatically "spool-up" to the first frame. Spool-off is automatic if the winder is used, and the film rolls up on the take-up spool tight and light leak-proof.

LENS PERFORMANCE

The RZ67 tested was requested and supplied with four lenses: the Mamiya Sekor Z F4.5 50mm, the F2.8 110mm, the F4.5 140mm, and the F8 500mm telephoto. The 500mm is currently the longest lens available for the RZ (and its cousin the RB67) and is 31mm in diameter and 105mm long physically. The angle of view is 10 degrees. The lens comes supplied in its own carrying case that also holds a rubber lens shade and tripod brace. The brace is a mounting bar with a hoop at the front end. The hoop has a pair of nylon "parrels" that allow the lens to slide freely through the hoop yet remain totally supported. Such an arrangement is mandatory for long lens work with the Mamiya because of the bellows focusing system. The mounting bar spreads the load and moves the center of gravity to suit the lens. The hoop provides the strain relief on the

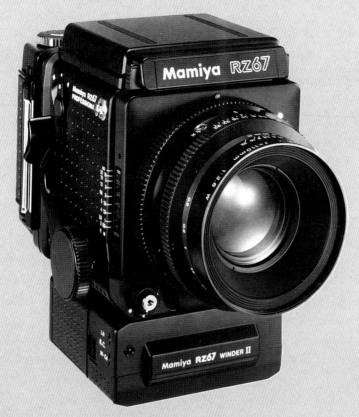

This RZ67 is fitted with auto-winder and an F2.8 110mm lens. (Courtesy: Mamiya.)

bellows and girders. The F8 500mm is an easy telephoto to work with and may, in a pinch, be handheld. There is an aiming sight on the front of the lens support to help with coarse aiming of the lens, although it is scarcely necessary. The optics are extremely crisp and well corrected, something Mamiya is noted for, and color saturation is superb and slightly warm.

The F4.5 50mm wide angle (angle of view 84 degrees) is another excellent optic, although, as with most wide angles, it will flare if pointed carelessly toward bright light sources. It is superbly free of aberrations, and is crisp and cooler than the 500mm but with equal color saturation. The 50mm exhibits no detectable distortions and is a good "general-purpose" lens for this camera.

With its floating element, the F4.5 140mm macro is a fine addition to the RZ67's armaments. Naturally, it is extremely sharp and well corrected, perhaps too cruel as a portrait lens, but can double as a general-purpose lens in

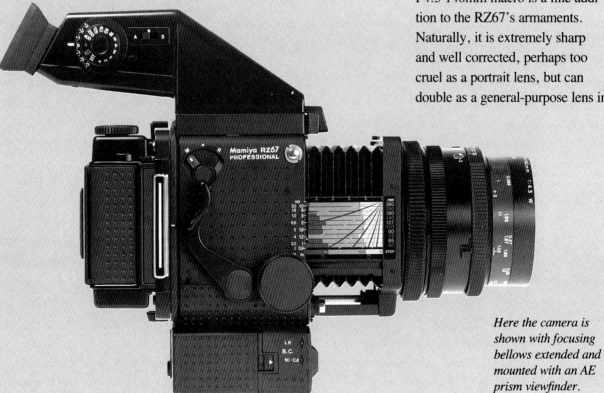

Here the camera is shown with focusing bellows extended and mounted with an AE prism viewfinder. (Courtesy: Mamiya.)

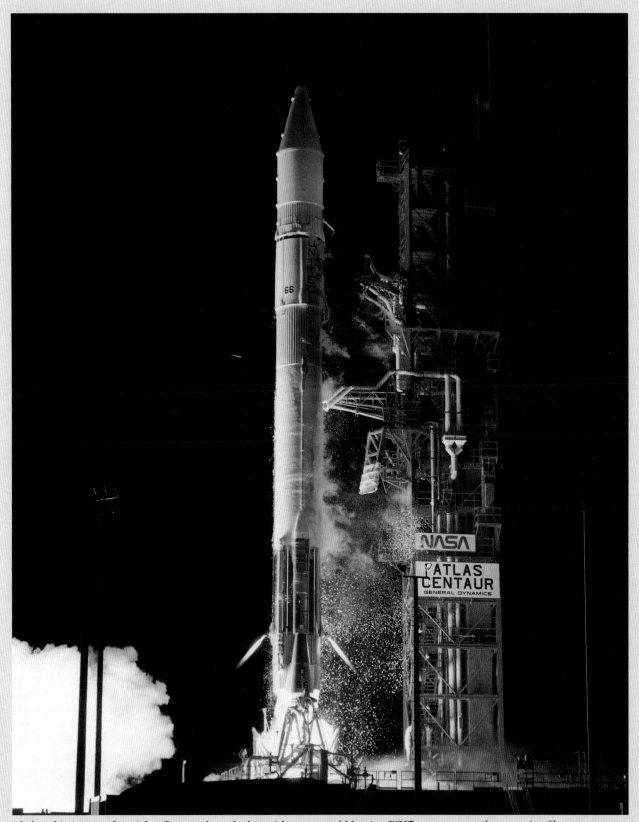

I shot this image of an Atlas Centaur launch shot with a remoted Mamiya RZ67 camera on color negative film.

a pinch. The incorporation of a floating element controlled by a separate ring on the lens barrel permits optimum correction across the lens' entire focusing range. In the conventional focusing mode the lens will focus from infinity to 75cm (2.5 feet) unaided. The closest focus image size at 75cm is approximately 1:1. At this distance, exposure compensation is necessary and may be read off the scales engraved on the bellows girder. If the AE metering prism is mounted, exposure compensation can be either automatic or manual and is computed TTL.

Finally, the F2.8 110mm lens is an excellent general-purpose lens with the same good optical manners as its siblings. All lenses feature depth-of-field preview levers, a flash synch-cord socket and cable-release mirror-up sockets, and "T" or time-exposure lock levers. The distance and depth-of-field scales are measured in feet and meters; data legends are clearly engraved on the lens barrels. Lens changing is swift and simple.

IN THE FIELD

The Mamiya RZ67 Professional and its lenses were tested using ISO 400 slide film to allow for comfortable handholding margins with shutter speeds and lens apertures. When I used it as a remote unit for the night launch of an Atlas-Centaur rocket at Cape Canaveral, I switched to color negative film because of the more forgiving exposure qualities of negative material. Film frame spacing is generally good although occasionally there was a bit of wandering. However, at no time did any frame overlap.

Attaching the RZ67 PD prism converts the camera to average or spot TTL ambient metering. It is not automatic—you still have to manipulate the lens aperture and shutter speed controls—but it does confer a useful degree of automation on the camera. It is especially convenient when working with long bellows extensions or macro lenses. For example, the exposure shift with the macro lens when working from infinity down to

closest focus without the extension tubes is 2 stops. On the other hand, the AE Prism Finder is fully automatic, and you can choose from three metering systems: spot, averaged, or "auto-shift." The latter switches to either spot or averaged metering depending on the level of light available. A metered manual mode is also provided for the LED operation or exposure compensation.

Flash photography is fairly standard as far as the camera is concerned. There is a hot shoe on the camera body with contacts that will relay "flash ready" information to the viewfinder when using the appropriate flash units. There is also a PC socket (prontor connector) on each lens for connection to independent or studio-type electronic-flash units, and it is possible to use both flash contact points simultaneously.

The rack-and-pinion focusing system of the Mamiya RZ67 takes a few minutes to adjust to, but after that it becomes swift and precise to use. This system also reduces the complexity and weight of the lens barrels by eliminating the need for a focusing helix. While the camera is not quiet, it is tough and quite weather resistant. Freezing doesn't faze it, nor does radiative heating. You must observe the usual protocols regarding batteries for both the camera and the winder in cold weather, but that's about it. I found it simple to set up as a remote unit, and it was reliable when left to work on its own. It is as much at home in the field as it is in the studio.

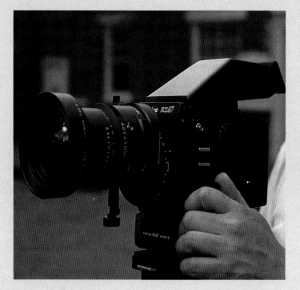

This photographer is working with a Mamiya RZ67 fitted with a perspective-control lens and an AE prism viewfinder. (Photograph by Butch Hodgson.)

MEDIUM-FORMAT RANGEFINDER CAMERAS

In the rangefinder area there is a terrific selection of cameras running from 6 × 4.5 right up to 6 × 17. Some of these have coupled focusing and some don't, especially those with very wide-angle lenses. In fact, Fuji offers six different model formats of 6 × 4.5, 6 × 7, and 6 × 9. Because Fuji opted for the compact folding camera approach, none of these cameras offer lens interchangeability. Mamiya has two rangefinder cameras that both offer lens interchangeability: the Mamiya 6, which is a 6 × 6 format, three-lens system; and the venerable Mamiya Universal Press which, although discontinued in 1989, is basically a 6 × 9 press camera with multiple-format capability and seven lenses ranging from a 50mm wide angle to a 250mm short telephoto. I had one of the early Mamiya Press cameras many years back when I was shooting for the BBC in London. By its very nature the Mamiya 6 × 9 Press was, and is, not a very quick camera, but its versatility was quite astonishing. The famous S-shaped standard rollfilm back was pirated and pressed into service on quite a few other cameras, one of which is the Plaubel 69w Proshift. This is still the rollfilm back of choice for those of us who like to build super box cameras.

There are enormous advantages to these rangefinder cameras. They are, with the exception of the Mamiya Press, reasonably small and compact. The Fuji Fujica

A Fuji 6 × 7 GW670II has one F3.5 90mm lens. (Courtesy: Fuji.)

These Fuji 6 × 9 rangefinder cameras, the GW690II and the slightly wider-angle GSW690II, also have fixed lenses. (Courtesy: Fuji.)

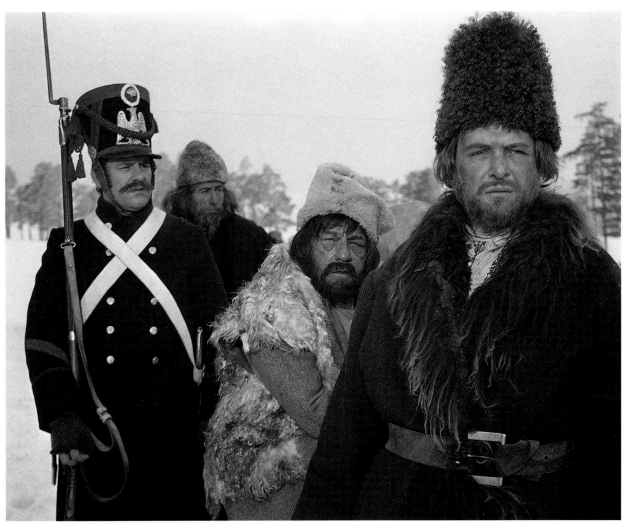

Actor Tony Hopkins, on the far right, played the role of Pierre in Tolstoy's "War and Peace." I photographed this group portrait with a Koni Omega Rapid 6 × 7 camera during filming of the BBC's version of this epic, which took over a year on location. (Courtesy: BBC.)

GS645W, for example, is noncoupled focusing camera (otherwise known as "guesstimation" focusing as it doesn't have any means of focusing other than looking through the viewfinder and guessing the distance to the subject) with detents, or click-stops, at 2 and 5 meters. It has a coupled exposure meter, a vertical format, and a big, bright-line (Albada) viewfinder with a between-lens shutter speeded from 1/500 to 1 second. The whole camera will sit comfortably on the palm of your hand, fits well in a briefcase, and only requires you to put batteries

in it for the meter and load it with film. They are quick, quiet, ideal traveling companions.

Back in the sixties there was a wonderful interchangeable lens, interchangeable back, 6 × 7 format rangefinder camera called the Koni-Omega. With two of those cameras I shot a number of large television productions for the BBC both in Europe and in North Africa. The cameras never faltered, and boy, were they quick. Unfortunately the Koni became extinct because the shutters gradually became more expensive to produce than the rest of the camera. You

may still find unused Koni's around, and they are a bargain.

About the only camera that fills the niche left by the Koni's is the Mamiya 6. Here you have a state-of-the-art, coupled rangefinder with interchangeable lenses and a coupled exposure meter. It is a 6 × 6 square format system with no interchangeable film backs, but it is elegant, well designed, and quite compact by virtue of the retractable lens mount. It has one of the best center-weighted exposure meters to come out in this type of camera. If the camera does have any faults, aside from illogicity of

the square format for this type of camera, it lies in the somewhat awkward placing of the focusing ring on the lens, especially on the 75mm standard lens. The focusing ring and aperture ring are too close together, and there is a tendency to grasp both rings at the same time. Otherwise, it is a beautiful and accurate piece of equipment.

WIDE-ANGLE/WIDE-FIELD CAMERAS

Outside the TLR and SLR medium formats are some interesting and unique cameras. Although generally used for special applications, these are essentially high-tech box cameras designed around a high-quality, wide-angle lens mounted in a focusing helicoid. Focusing is usually noncoupled, and aiming is through an auxiliary optical finder. These cameras look as deceptively simple as they are expensive.

Hasselblad took the classic Zeiss Biogon F4.5 35mm CF lens, mounted it in a lens barrel with a leaf shutter, and came up with the Hasselblad 903SWC camera. This is one of the few non-SLR variants

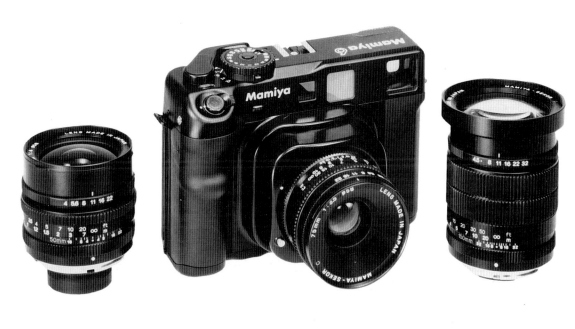

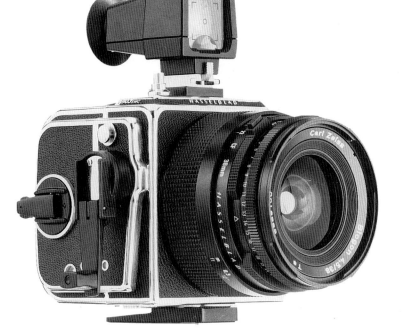

The new Mamiya 6 rangefinder camera has interchangeable lenses and coupled focusing. (Courtesy: Mamiya.)

The Hasselblad 903SWC is designed around the Zeiss Biogon F4.5 38mm lens. (Courtesy: Hasselblad.)

If carefully used, the Hasselblad 903SWC is well suited to architectural subjects. (Photograph by Ernst Wildi, Hasselblad.)

in the "Hassie" line. The camera's body is a slim unit fitted with the typical Hasselblad fold-out film advance crank and an optical viewfinder mounted in the accessory shoe. Because the Biogon's rear element is so close to the film plane the camera cannot be an SLR, and so the Hasselblad 903SWC is a member of the guessimation-focusing group of cameras.

The 903SWC is a very popular camera for working in cramped spaces, and is ideal for shooting interiors. It is also excellent for general work. The square 6 × 6 format may be modified by means of alternative backs and masking frames to match the viewfinder to the format. Naturally, the shutter supports full flash "X" synch at all speeds. You can also remove the film back and substitute it for a ground-glass focusing screen. Of course the image is inverted, but it does make for more accurate viewing. Focusing hoods, magnifiers, and other aids may be fitted over the screen for easier viewing. These take away the immediacy of the camera, but, for precise work, that can't be helped. The Zeiss Biogon lens has a diagonal angle of view of 90 degrees horizontally (72 degrees assuming the full 6 × 6 format). The lens has excellent overall light transmission and requires no special center filter for even light distribution.

Another useful wide-angle camera is the Plaubel 69w Proshift, which unfortunately seems likely to become extinct. It features the immaculate Schneider Super An-gulon F5.6 47mm lens with a standard 1 to 1/500 sec. between-lens shutter. Like most wide-angle lenses of its type, light transmission usually rolls off towards the edge of the negative (optical vignetting). This is unavoidable and is remedied somewhat by the use of a special neutral density (ND) center-filter. The maximum effect of a precisely manufactured variable ND filter is at the center and cancels the light fall-off towards the edge of the frame. Such filters are offered for most wide-angle, wide-field cameras. They work fine, but with a lens that is only around F5.6 to start with, center filters subtract at least two more stops. Thus, if working at $f/22$, you should ideally adjust the exposure down to $f/11$. Consider this when thinking about the film type and ISO rating to be used. Truthfully, you can get away without using the filter about 60 percent of the time, burying the roll-off into darker areas of the image.

Back to the Plaubel though, which has a couple of interesting capabilities that make it rather adept. The front panel and lens may be shifted sideways 13mm and vertically 15mm from center. These shifts are large and quite useful for correcting the image at the film plane. The lens covers 93 degrees across the diagonal so the shifts are well within the lens' projected image circle. The optical viewfinder is coupled to the lens panel to tilt in accordance to the vertical or sideways shift. The finder also has a parallax correction lever. The 6 × 9 rollfilm

The Plaubel 69W Pro-shift has a Super An-gulon F5.6 47mm lens and a body designed around Mamiya's roll-film holder. (Photograph by Bruce Weaver.)

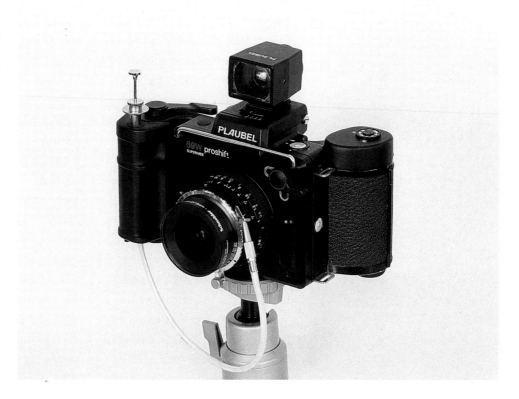

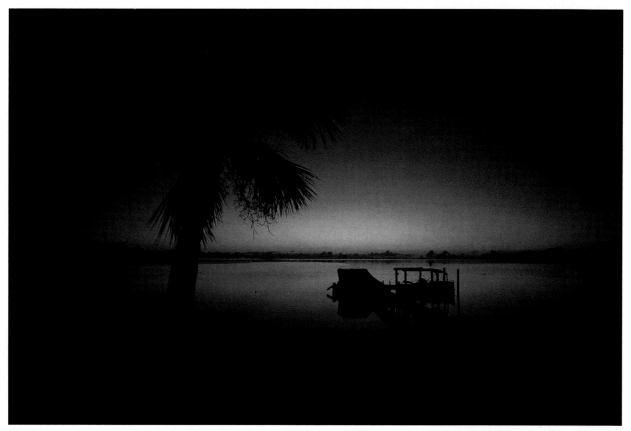

At dawn on the Indian river in Old Titusville, Florida, I took this picture with a Plaubel 69 Pro Shift and a 47mm Super-Angulon lens without using a center filter.

back can accommodate 120 or 220 film and will instantly be recognized as the ubiquitous Mamiya S-shaped rollfilm back. So why go to such lengths to describe a camera that may not be around much longer? Well, there are a lot of them around, they don't wear out, plenty of new ones are still on the shelves, and the used ones are perfectly serviceable. Besides, because the camera is so simple, any competent repair technician should be able to fix it. After all, it is a hybrid.

PANORAMIC CAMERAS

Linhof offers two wide-angle medium-format cameras, the Linhof Technorama 612PC and the Technorama 617. Both are equipped with the Schneider Super Angulon lenses. The 612PC is, as its name implies, a 6 × 12 format camera, the lens is a F5.6 65mm with a between-lens shutter by Copal, and the camera has a 91 degree angle of coverage. But the 612PC has a slightly peculiar design quirk that only Linhof could endorse! The lens panel is offset vertically by 8mm, which is, in effect, a rigid rising front. The theory behind this is that when the photographer aims the camera at a building, there will always be too much foreground in the frame. The temptation is to tilt the camera slightly so that the bottom of the building sits on the bottom of the frame. A logical solution, but actually bad practice because this now causes verticals to fall inward or converge toward the top of the

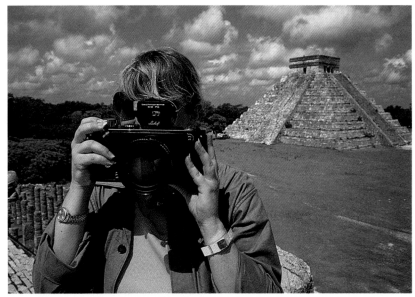

I captured Arlene Muzyka on location in Chitzen-Itza, Mexico, hoisting a Linhof Technorama 612PC.

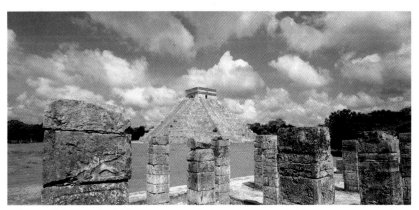

Then I photographed Chitzen-Itza with the same camera Arlene was using. With wide-field systems it is imperative to keep the camera level. Using a small lens aperture permitted great depth of field in the image, which effectively utilized the foreground masonry in this picture.

frame. Why? Because the top of the image is actually farther away from the film plane than the bottom because of the tilt. "O.K.", says Linhof, "if we build in a vertical rise, this will help avoid the problem." It is beyond understanding how this concept arose because the camera must be held level on both a horizontal and the vertical axis to avoid even more grotesque distortions to the image.

The built-in vertical shift is simply a non sequitur, especially when you use the camera vertically; then the shift would be to the left or right, a useless correction.

Despite all this, however, the Linhof 612PC is an excellent panoramic camera and a fine traveling companion. An expedition I took to the Yucatan peninsula to photograph the Mayan pyramids and ruins proved the camera's worth.

All the pictures had to be shot hand-held, and some of the handholding speeds were horrifyingly slow despite film speeds of ISO 400 and faster. The center filter had to be used in many instances because of the huge expanse of sky often included in the pictures. The 612PC is also an interchangeable lens camera. In addition to the Super Angulon 65mm, there is a Sonnar F5.6 135mm lens designed for it. Naturally, when you mount the 135mm lens, it becomes less of a panoramic camera and you certainly lose the dramatic effect of the 65mm. The 135mm lens is of limited utility, but handy to have when you simply require a bit more reach. Like the 65mm, the 135mm is locked into the built-in vertical shift. The camera is equipped with a bright line optical finder with appropriate parallax correction frame lines.

The Linhof 617 Technorama is one of my all-time favorite panoramic cameras. It became briefly extinct because Linhof argued that the 612PC was adequate; but the howls from professional and advanced-amateur photographers who specialize in wide-angle images helped bring it back. It also returned with some well thought-out design modifications suggested by concerned professionals. The camera's format, 6 × 17, is big and resembles the classic ''Cinemascope'' movie screen. The lens is the Super Angulon F5.6 90mm with a between-lens shutter by Copal and a focusing helix. As with the previously mentioned Super A's, the lens does require a compensating center filter to optimize

The power and sweep of a panoramic camera is seen in these images of Monument Valley, Arizona, both taken with the Linhof Technorama 617. (Photographs by Butch Hodgson.)

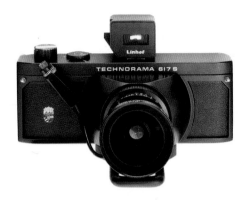

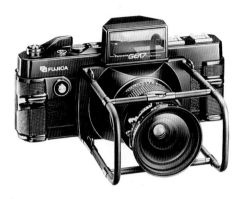

The Linhof Technorama 617S, shown top right, has a Super Angulon F5.6 90mm lens. (Courtesy: Linhof.) Beneath it, the Fuji G617 Panorama Professional has a built-in roll cage to protect its huge Fujinon F8 105mm lens. Notice the spirit level on the roll cage. (Courtesy: Fuji.)

"Look down, shoot down." And so I did, 100 feet above the George Washington Bridge, with the Fuji G617 camera on Fujichrome 100.

light transmission across the field. But, if there is any justification for the use of a panoramic camera, the 617 Technorama is a prime example. The images are simply gorgeous. You get only four frames using 120 film (double that for 220 film), and you have to think carefully about the image to make each frame count. The old adage of not getting caught short should always be kept in mind when using panoramic cameras.

Fuji produces a lot of interesting rollfilm cameras, but the most elegant and useful to me is the Fuji G617 Panorama Professional. Comparisons to the Linhof line are expected, and some people insist that the G617 is just a Japanese

version of the Technorama 617. There are similarities. Both are panoramic cameras, and they both shoot 6 × 17 frames on 120 or 220 film. But the Fuji G617 employs a Fujinon EBC F8 105mm SW lens with a 170mm diagonal and a direct-vision viewfinder. Focusing is noncoupled via a focusing helix with a Seiko between-lens shutter, speeded from 1/500 to 1 second plus ''B.'' Flash synch is ''X'' at all shutter speeds. The closest focus is about 15 feet or 5 meters; and, like all other cameras of this type, it exploits the apparent deep depth-of-field produced by a short focal length. The 105mm Fujinon doesn't really require a center filter

because the light roll-off is minimal. You might notice it when shooting across a uniform tone such as a wide expanse of sky, but it is far less than the effect produced by the Super Angulon.

Opinions vary, but actually the Fujinon 105mm is not a very wide-angle lens, so the camera is best described as a wide-field camera. Surprisingly, the view finder is somewhat basic in that it has no bright-lines etched in it. This is a bit disconcerting at first, but you soon learn to work with it. There is a built in ''roll cage'' on the front of the camera designed to protect the huge lens element. This cage also carries a horizontal spirit level that may be seen through the

finder. It cannot be stressed how important it is to get a level horizon with panoramic cameras. Where there is any horizon reference, the slightest tilt will spoil an otherwise good shot.

Remember that panoramic cameras aren't used like most other cameras—specifically 35mm models—to squirt off hundreds of frames. It was George Bernard Shaw who described the 35mm camera as, ''a codfish that lays a million eggs in order that one may survive.'' This might be exaggerated, but he did have a point even if he didn't understand the esthetics of camera formats. The Fuji G617 Panorama has accompanied me to every launch of the NASA

space shuttles; and it is this camera that, to my mind, despite all the remote cameras and long-lenses 35mm's, made the definitive launch picture, one that captures not only the shuttle as it leaves the pad but the overall environment (see page 84). It is quite exciting to stand at the edge of the lagoon by the press site at Kennedy Space Center and pick off four carefully aimed and composed shots during the brief and noisy flurry of a launch. The Fuji G617 is a quiet, unpicky camera with nice ergonomics and a wickedly sharp lens.

ROTATIONAL SCANNING PANORAMIC CAMERAS

Several medium-format cameras can shoot huge panoramic pictures of up to 360 degrees by making

The Alpa Rota rotational camera renders a 360-degree image. (Courtesy: Karl Heitz, Inc.)

Here I set the Alpa Rota camera to shoot a 180-degree pan.

the lens rotate around the film plane, thereby scanning the image onto the film (in fact, the lens rotates one way while the film is moved in the opposite direction). Exposure is made through a small vertical slit that acts as a shutter. One of the most elegant of these is the Swiss-built Alpa Rota 70 Panoramic camera. It will provide distortion-free images at 90, 180, 270, and 360 degrees and also permits intermediate angles selected via the rotation selector ring.

What is interesting is that the Alpa Rota 70 is actually a true medium-format single-lens-reflex (if a negative frequently as long or longer than 600mm may still be classified as "medium"). There is a vertical viewing port that permits the photographer to determine the best starting point in the scene for the scan to begin. When the camera starts its rotation, the reflex port is closed automatically by a shutter to prevent light from penetrating into the system.

The rotation is driven by an electronically governed electric motor that silently and very, very smoothly rotates the camera around its axis. One of the prob-

lems with scanning cameras of this type has always been to get the camera to make its full rotation at an absolutely constant speed. This is important because the scan speed actually governs the exposure; the faster the scan the faster the apparent shutter speed. An inconsistent scanning speed causes unequal exposure on the film called ''banding.'' At worst, the image will have sharply defined vertical streaks of different exposure. There are a number of reasons why this occurs, most of them mechanical. If the system is spring driven, the uneven unwinding of the spring causes acceleration and deceleration. Also, the inevitable wear of meshed drive-gear teeth will cause the motor to vibrate, or judder.

The Alpa Rota is electronically governed, and I've actually used this camera as a remote unit at a shuttle launch in Cape Canaveral. (The only problem was making the camera weatherproof. Later experimenters solved the puzzle—the housing has to rotate with the camera—by bolting a plastic bucket upside down over the top of the camera and cutting a small slot for

the lens to look through. This tactic was quite successful despite its makeshift appearance.) There are five shutter speeds obtained by varying the width of the slit in the lens and the rotation speed: 1/250, 1/125, 1/60, 1/30, and 1/15 sec. The rotation speeds are fast (2 seconds) and slow (3 seconds) in order to accommodate a 360 degree scan. The lens is the famous Rodenstock Grandagon F6.8 75mm fixed-focus lens that offers 30mm perspective control and may be stopped down to $f/32$ for maximum depth-of-field. This enables distances as close as 12 feet to be in focus. There is even a special bracket that permits the camera to be mounted upside down! The lens has a vertical angle of coverage of 42 degrees on 70mm film and 38 degrees on 60mm rollfilm (the more familiar 120 or 220 material) and a filter size of 58mm.

Basically the Alpa Rota is a 70mm camera, accepting standard 70mm cartridges with film loads of 15 to 22 feet. And by adjusting the film channel you can still use 120 or 220 rollfilm. Power for the camera is through a rechargeable 12V, 1.2 amp battery pack. The

system is not lightweight and does require a very efficient and stable tripod. The images are, to put it mildly, interesting. Because the lens rotates away from an object nearest to it, the image appears to diminish on either side of that point. On the other hand, if you were to photograph a large group of people and asked them to stand in a circle at a given distance from the camera, everyone would be in the same proportion. Scanning panoramic cameras take a bit of getting used to because of their distortion, but such cameras play an important role in photography, and when handled creatively can produce gorgeous results.

Printing from a 360 degree negative can be a puzzler, and not many labs are equipped to do it. But there are a number of approaches, and one way is simply to contact print the negative. The other is to find a lab that can handle at least a 180 degree panorama by printing it in an 8 × 10 inch enlarger. For longer panoramic shots, the best solution is to have a reduced internegative made and then use it to print to the desired size.

HYBRID-MODULAR CAMERAS

We should not leave this area without a passing reference to what might be described as hybrid-modular medium-format cameras. The Linhof Technar is a prime example. Essentially a wide-angle, handholdable 4 × 5 camera, it can be converted to rollfilm format by substituting either a Super-Rollex, Techno-Rollex, or Rapid Rollex back. Lenses available are the Super Angulon F5.6 65mm, F5.6 75mm, and the F5.6 90mm. The Linhof may be like the other wide-angle cameras discussed, by using a bright-line finder, or a ground-glass focusing screen.

A number of similar cameras are offered by different manufacturers. One interesting machine is produced in Italy by Sylvestry. This camera features the Super Angulon lens set in a leaf shutter with a focusing helix. The whole assembly has shift capability and may be moved 15 degrees to either side. Because the lens panel is removable, other focal lengths may be employed. Focusing is by a ground-glass screen substituted for the film back. The camera has a rotatable 6 × 7 rollfilm back and is basically a traveling technical camera for the medium format user. It is not a camera that is easily handheld because of the general configuration, but it is quite possible to use it without a tripod if you are willing to invest in using an optical viewfinder, an accessory that is easily attached.

There are a number of other wide-angle 4 × 5 systems that readily adapt down to rollfilm back use and thus qualify as medium formats. Calumet, for example, offers their Cambo Wide 900, which features the ubiquitous Super Angulon F8 90mm lens. Despite the equipment, panoramic photography is still fairly basic. You might need to learn a few technical things, but if you apply the ''sunny sixteen'' exposure rule, you'll get fine pictures.

The Linhof Technar 4 × 5 camera can be used with a variety of film backs. (Courtesy: Linhof.)

INSTANT CAMERAS

Instant-film photography is not any more esoteric than conventional photography. Film is film. The difference lies in the fact that the instant-film pack carries the processing materials in a pod on each piece of film. The only drawback is that with most of the images, each photograph is unique. If you want enlargements or copies, you have to re-photograph the original.

The medium-format instant camera, generically referred to as the Polaroid, always seems to get overlooked in the melee of medium format. Nevertheless, the Polaroid Spectra Pro and the recent Minolta Instant Pro are medium-

This Polaroid instant print was made in the Mamiya RZ67 Polaroid film back. This interchangeable back allows you to check an image on instant film before taking the final shot. (Photograph by Butch Hodgson.)

I shot this print with a Polaroid Spectra. Instant it may be, but despite Polaroid's opinion to the contrary, it is still medium format.

Data marks on film made by photogram-metric cameras indicate size and distance of the subjects, whether they be a shuttle landing or a car wreck. (Courtesy: Rollei and NASA.)

format cameras. Most readers are familiar with Polaroid cameras in one shape or another. Their final images measure some 9 × 7cm, and the instant-film pack delivers 10 shots per pack. The Spectra Pro gets its name from the fact that it can perform some fairly sophisticated professional tricks such as multiple sequencing and multiple superimposition. The lens is an all-glass optic for improved definition. Autofocusing is achieved by sonar, the classic Polaroid sound/echo location process, and the exposure for both flash and ambient light is automatic. The Spectra doesn't do well in the shutter-speed sweepstakes, the fastest being 1/245 sec., and the slowest up to about 2 minutes. One thing though, it does offer enormous depth of field when stopped down to the smaller lens openings such as f/45, which can be a great advantage when shooting scenics.

Of course, as the reader may have noted, there are literally dozens of Polaroid backs for conventional cameras in all formats. Polaroid images have saved more than one reputation by letting the photographer check the image for color and exposure quality before the final shot. And instant photography, no matter what level it is approached from, is an art in it-self. So should the Spectra be considered as a truly professional tool? Interestingly enough, such systems score highly with professionals who are not necessarily photographers: medical practitioners, engineers, or in short, anyone who needs a quick color picture on site. So although the Spectra Pro may be a ''pro'' in name only, it does have quite a wide professional application among discriminating amateurs.

PHOTOGRAMMETRIC CAMERAS

There are a number of medium-format cameras primarily designed for scientific use. Photogrammetric cameras, or adaptations of medium-format cameras to such purposes, are by no means rare; Rolleiflex, Bronica, and Hasselblad offer them. Some of the most famous must be the modified Hasselblads that went to the moon. They can be used in a conventional manner, but it would be an expensive solution to the problem. Most of these cameras have what are called Reseau plates fitted in front of the film plane. These plates have very precise datum marks etched on them, which in turn are photographed onto the film or image. The purpose of the data symbols is to provide an ac-curate image scale for the photograph. If you know the size, position and spacing of the marks on the plate, the focal length of the lens, and the distance, you can calculate the size or scale of the object photographed. These references are useful when assigning the landing area of a lunar lander, or determining how far the skid marks extend in a fatal road accident.

Obviously this chapter didn't cover every camera available in each class, but the idea was to convey the general function, configuration, and application of some different medium-format cameras. Remember that simplicity in a camera is no crime. Too often emphasis is laid on automation, and while automation is good for supporting a beginner, it doesn't teach photography. Basic photography is not really difficult to learn, although at first it might appear so. Medium-format cameras are somewhat automated and quite successfully. Current automation consists of autoexposure and certain computer-driven functions, especially where the computer chip can speed up the reaction time of the camera. Surely an engineer will soon find a way to incorporate standard autofocus into most medium-format systems.

LENSES AND OPTICAL PRINCIPLES

A simple pin-hole camera can certainly be used to take some interesting pictures, but it has many limitations in quality and speed. With the modern, advanced technology lenses, cameras are capable of some breathtakingly sharp images saturated with color. Back in the dark ages of photography, Zeiss, Leitz, and Schneider produced excellent lenses and established the benchmarks in optical quality. They were not inexpensive then, and they are surely not inexpensive now. In the early 1950s, the Japanese began producing lenses that were often equal to, and occasionally better than, the best traditional European products. And at that time, they were a lot less expensive. Today though, there is very little difference in total quality between the two sources.

Of course, the blessings of a larger format can also be its bane. Larger formats are usually much more demanding of their optics than 35mm needs to be. Larger lens elements required for larger frame areas are more difficult to make and more time consuming in the process. A 35mm lens designer has appreciably more leeway in the production of the lens; lenses can be produced with a larger image circle and more of the central area of that circle can be used for optimum quality in image production. For medium format though, the lens barrels, shutters, focusing mounts and all the electro-mechanical support systems are much larger.

Although I said that lenses for large format have to be better than those for 35mm, this is actually a half-truth. Yes, you have to enlarge a 6 × 6 frame less than a 24 × 36mm frame to make an 11 × 14-inch print; but if you enlarge both formats pro-rata, you will see that the theory is only a theory. Lack of quality in a lens will be evident irrespective of the format size. Like depth of field, quality depends on how much you enlarge the final image. Perhaps the single best piece of advice that can be given is to buy the absolute best lenses you can afford. It is better to have fewer lenses that are the best the optical engineers can produce than to have a whole arsenal of substandard optics.

Another thorny question comes up. Should you always buy original equipment manufacturers (OEM) optics, or are lenses produced by independent companies just as good? Knowing the old adage "you get what you pay for," how do you make the decision and avoid getting stuck with a "dirtball" lens? This is where experience and a little help from your friends comes in. If you have friends who are photographers and own some of the lenses you'd like to buy, by all means ask their opinion. Beware though; devotees of a particular lens manufacturer may well be like lovers who see no fault. Be skeptical. Ask if you can borrow the lens and shoot some of your favorite film with it. Do a little research on the lens you are interested in buying. Photographic magazines generally offer honest appraisals of equipment and are more than willing to advise you. Again, technical writers are variable animals, so stick with the names you recognize for advice. The marrow of the situation lies in whether you can borrow the lens and shoot your own tests. And don't try to redefine the manufacturer's MTF (multiple transfer function) curves—you can't.

One thing you can do to get a feel for the quality of the lens is to shoot a controlled test series in constant light levels. Pick a good sunny day, and give the lens a thorough work-out. If it is a zoom, don't forget to go through the lens' entire ratio. Frequently what's good at one end may not be good at the other. Watch for any drift in the parfocality of the lens; that is, check to see if it stays in focus

On top is a cross-section of a Planar lens and beneath it are the various components that make up these glass jewels. (Courtesy: Rollei.)

I exposed this Florida landscape using a Fuji G617 wide-field camera on Fujichrome ISO 100. Notice the light fall-off toward the edges of the image. A center filter would have helped to alleviate this problem.

when you zoom. If it is a true zoom lens, it will. Watch for differences in the final image as you go through the stops. Carefully check the slide or negative for equal light transmission across the whole negative. (An exception to this will be when using very wide-angle lenses covering the longer formats. For example, the Zeiss Biogon 38mm covering 6 × 6 will show no fall off. The Schneider Super Angulon 47mm covering 6 × 9 will. That is why center filters are made for these lenses. It is an inevitable product of the design and the laws of optics.)

If you are checking for light transmission across the format, or simply want to know if your lens and shutter are accurate, try this

test: Select a large area of a single continuous tone, preferably a white wall. Make sure that it is evenly lit and make sure the camera and lens are absolutely parallel to the target. Shoot from the maximum aperture right down to the smallest, adjusting the shutter speed accordingly; the exposure for each picture should be constant. That is, if you start at $f/2.8$ at 1/500 sec., then $f/4$ should be at 1/250 sec. Process the film and take a look at it on a good light table. If you see nothing except an evenly lit frame area for each shutter speed and lens aperture, everything is just fine. If you see changes in the image density, say the image is slightly darker or lighter at the center and tapering

off to the edge, then there may be a problem. Even very expensive lenses and shutters display this anomaly, and if it occurs, query the manufacturer about it.

Generally, you can take a lens straight out of the box and start using it with no qualms. But even so, any photographer worth his salt will test all new equipment to see if it does indeed perform to specification. In short, be an educated consumer. It is your money, and just because it has "Zeiss" or "Nikon" stamped on the lens doesn't mean that it is inviolate. If an independent maker's lens lives up to your expectations, then fine. One of the nice things about independent lens manufacturers is that they aren't constrained by tradition

and will often come up with very innovative designs to benefit the photographer.

FOCAL LENGTHS

Generally lenses are classified according to their focal length. Usually this is considered the power of the lens and is some indication of its actual use and physical size. Obviously 38mm is shorter than 250mm both physically and optically, and it is natural to assume that a 38mm lens on a medium-format camera would be quite a wide angle. Conversely, it would be proper to assume that the 250mm lens would be some sort of telephoto. The general assumption is that a lens with a focal length of the approximate diagonal of the

negative would be a "standard" lens. Thus, 80mm is usually considered "standard" for 6 × 6 cameras. If the focal length exceeds the diagonal, then it would be a telephoto lens; the longer the focal length, the greater the effect. Conversely, if the focal length is less than the diagonal, then it is a wide-angle lens.

Here are some approximate figures that relate the format diagonal to the focal length of standard lenses. They are only approximate because manufacturers generally "round off" odd focal lengths; for example, the diagonal across a 6 × 6 (60mm × 60mm) negative is actually 79mm, but 80mm is considered standard. And just to make life difficult, a 6 × 6cm

negative is really 55mm × 55mm! By this criteria the standard lenses for some formats are: 104mm for 6 × 9, 90mm for 6 × 7, 80mm for 6 × 6, and 67mm for 6 × 4.5. It follows that if you took a 90mm lens and made it cover for a 6 × 17cm negative, you would be looking at a wide angle. Conversely, if you used the 104mm lens on 6 × 4.5cm, you would have a short telephoto.

The focal length of a lens need not be its physical length. In fact, there are instances where the lens design permits an optical length greater than the physical length. The most definitive example of optical reality being longer than physical reality is manifest in mirror or catadioptric lenses. In these lenses the light is shuttled backwards and forwards, down, up, and back down the optical path by means of a set of mirrors.

There are essentially two types of mirrors employed in systems like this. The first are front-surface mirrors where the reflective coating is on the front curved surface of the mirror, and the light never penetrates the glass or ceramic that forms the mirror. The other are rear surface (Mangin) mirrors where the light is allowed to pass into the glass of the mirror and is reflected back from the coating on the rear curve of the mirror. There are some advantages to this. If light has to pass into any reasonably substantial medium—such as glass—it is refracted, or more simply, the light path is changed. This

From top to bottom, these four shots depict the increasingly longer focal lengths of 50, 75, 90, and 180mm. (Photographs by Butch Hodgson.)

could be exploited to add magnification to the image by lengthening the ray path, and hence produce a very compact mirror lens. A Cassegrain lens is a mirror lens system where a hole has been bored in the center of the main mirror. The light entering the front of the lens impinges on the main mirror and is reflected back up to a secondary mirror placed near the front of the lens barrel. The light rays are then reflected back down the barrel and through the hole in the mirror to the film plane. A catadioptric lens is essentially a Cassegrain mirror system with additional lenses to increase the magnification of the image and introduce additional optical corrections. Catadioptric lenses are physically much shorter than a conventional Cassegrain—which in turn is physically shorter than a conventional refractor type lens—but supplies much greater image magnification. For the most part though, lenses for medium-format cameras are generally refractors, that is, lenses where the light passes through the glass elements to produce the necessary image size and optical corrections.

The focal length of a lens is always a constant except for zoom lenses. For example, a 250mm lens remains a 250mm lens unless you add to or take away from its power with additional elements (for example, tele-converters or closeup lenses). But a zoom lens is designed to change focal lengths. If it had a focal length range of 100 to 500mm it could produce an

infinitely variable combination of focal lengths between those two limits. There are currently far more prime lenses for medium-format cameras than there are zooms, but the zoom lens is slowly becoming the universal lens for 35mm cameras. Sheer physical weight and dimensions tend to preclude this in medium format.

COVERING POWER

Earlier I explained that putting a 90mm lens on a 6 × 17 format would produce a wide-angle camera. Does this mean then that lenses are readily interchangeable from camera to camera, and format to format? Sorry, no. If only life were that simple. Mechanical configuration such as lens barrels, lens mounts, and electrical and mechanical links are all different camera to camera. Also, a lens projects an image circle, and it is that area, masked off by the camera gate or the film-back opening, that produces the desired coverage.

Apart from the obvious requirements that the image be square or rectangular, not all of an image circle is suitable for the final image. Actually only the best area is masked off and used. Each format requires that the lens "throw" a greater image circle to cover the negative area. This explains why a 100mm lens for a 35mm camera is physically smaller than a 100mm lens designed to cover 6 × 6 or 6 × 9cm. It is technically possible to have a lens designed to cover a larger format work perfectly on a smaller format, but that is what interchangeable film backs

of different calibers are about. It is also true that the 100mm lens designed for a larger format will, when used on a smaller format, become an effective telephoto. Rollei exploited this years ago when they offered a 35mm film

conversion system that went into the gate of the 6 × 6 TLR. A 100mm lens designed to cover the 24 × 36mm frame would not be useful shooting into the 6 × 6 frame unless you like disc-shaped pictures with fuzzy edges.

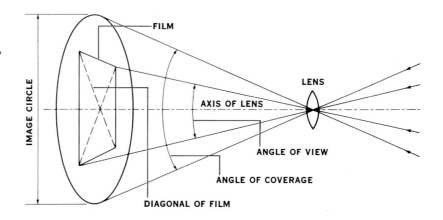

The angle of view is the amount of the scene that is covered by the lens. The image circle must be larger than the film area for the entire surface of the film to be exposed.

This range of Schneider lenses for the Rollei 6008 includes a teleconverter. (Courtesy: Rollei.)

SELECTING A LENS

It might be profitable, at this point, to give some comparison data by which to judge which focal length lens best suits your work. Most people are familiar with the jargon for 35mm; they know that a 28mm is a moderate wide angle, 135mm is a short telephoto, 500mm is a super telephoto, and so on. They have a visual picture of what the focal length will do. Transferring this visual image to medium format is not quite so simple. Angle of view would be a useful reference, if only the manufacturer gave the angle of view in both horizontal and vertical orientations. Alas, the angle of view is often quoted as the diagonal, and a fat lot of good that is! For example, if you are working in 6 × 6 with an 80mm lens, the optical engineer will quote an angle of view of 52 degrees. The reason is most logical. A lens projects a circular image, and in the case of a 6 × 6 format, the 60 × 60mm frame must drop into that circle, with a bit of room to spare; otherwise the light would fall off towards the edge of the image. With some ultra-wide-angle lenses, photographers have learned to live with this phenomena, and if the fall off is irksome, a center filter can be used to compensate. The actual horizontal angle of view for a 80mm lens in a 6 × 6 format is 38 degrees. Remember that the 80mm lens is considered standard for 6 × 6.

As a photographer, you are primarily interested in what the lens sees horizontally and vertically. For example, if you are shooting a scene and the camera is horizontal and level, it is useful to know where the lens "hits the ground," or, where its vertical angle of view brings the foreground into the picture. A fish-eye lens with 180 degrees angle of view actually hits the ground at your feet which would be included in the picture! Of course you can see this through your viewfinder, but you'd be surprised how many photographers get into trouble with unwanted items in their pictures.

Where the angle of view is quoted across the diagonal, the horizontal and vertical angles change according to the actual format used. If you decrease the vertical dimension of an image from 6 × 6 to 6 × 4.5, the horizontal angle of view stays at 38 degrees, but the vertical shrinks to 28 degrees. You get the idea. In order to bring all of this into perspective, here are some comparisons between 35mm (24 × 36mm) and 6 × 6cm (55 × 55mm) formats. It is fairly easy to estimate focal length differentials for the other formats once you have a mental image to refer to when making comparisons. Notice that an appreciable increase in focal length for 35mm is needed to achieve even moderate telephoto effects in medium format.

35MM FOCAL LENGTHS	6 × 6CM FOCAL LENGTHS	6 × 6 HORIZONTAL ANGLE
20mm very wide angle	31mm very wide angle	84 degrees
24/25mm wide angle	38mm very wide angle	72 degrees
28mm moderate wide	43mm wide angle	65 degrees
35mm just wide angle	54mm wide angle	54 degrees
50mm standard	80mm standard	38 degrees
100mm short telephoto	150mm portrait/macro	21 degrees
200mm moderate telephoto	300mm approx. telephoto	10 degrees approx.
300mm telephoto	450mm approx. telephoto	7 degrees approx.
327mm approx. telephoto	500mm medium telephoto	6.5 degrees

I took this sunrise in Florida with a Mamiya 6 camera and an F3.5 75mm lens in autoexposure mode on Fujichrome film.

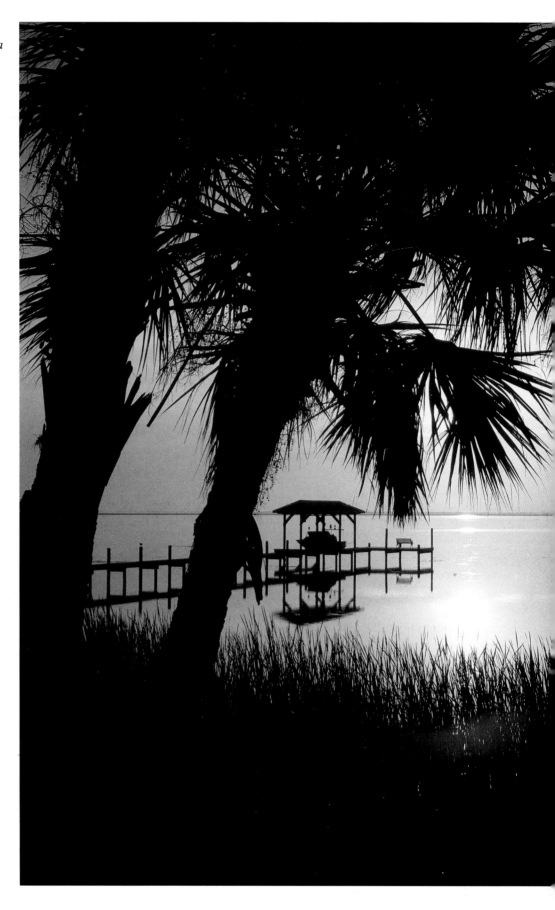

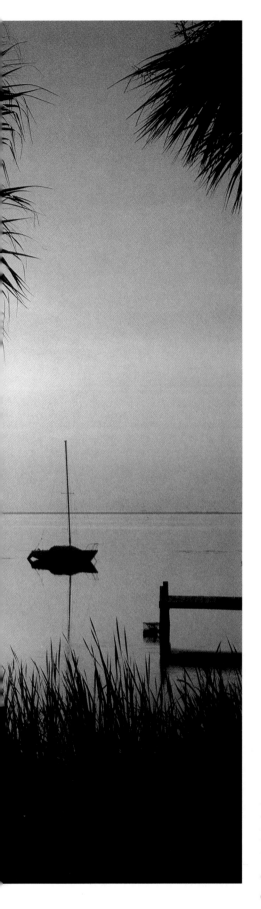

THE STANDARD LENS

There are very few fast lenses for medium format, and the few that do exist are basically designed for 6 × 6. The average fast lens for medium format is F2.8. There may be one or two lenses coming into the market, roughly around 100 to 120mm for 6 × 6, that are also F2.8, but, as of yet, not too many. The problem is not the design but the sheer physical size of the lens as you increase its speed. A fast lens designed to cover 6 × 6 is going to be much larger, heavier, and bulkier than a slower one. Add to this the requirements for shutters—if it is a between-lens shutter system—and control linkages, and you can see that on average, the larger the format, the slower the lens will be overall.

One way to counter lack of speed in medium-format lenses is to shift to faster film speeds. This is a good solution provided that you don't waste what you gained in format size by using film of a lower resolution and image quality. It is quite difficult to get into serious grain and resolution trouble with modern rollfilm emulsions. Personally, I usually choose slower emulsions and use a faster aperture with its decreased depth-of-field. Although the habit of stopping down a lens for sharpness is ingrained in most photographers, it isn't entirely necessary, except to get better depth-of-field. High quality lenses perform just as well wide open as they do stopped down. Of course, the faster the aperture and film, the easier it is to

use the camera handheld. However, there are not that many fast lenses for medium format so the photographer needs to exploit all possibilities.

Standard lenses are good compromises between focal length, overall perspective, and speed. The Planar F2.8 80mm lens on the Rolleiflex 6008 is an excellent general-purpose lens. It is acceptable, if not ideal, for portraiture and interiors, but it is perfect for most general photographic chores. In addition to being superbly corrected optically, it features a useful maximum aperture that allows the use of most film speeds from the slowest to the very fastest.

TELEPHOTO LENSES

Technically, any focal length greater than the diagonal of the format becomes a telephoto. This has led manufacturers to take quite a bit of liberty with the concept of a telephoto lens. A while back, Rollei introduced the beautiful Tele-Rolleiflex TLR with its fixed Sonnar 135mm. This focal length for 6 × 6 was really not a great telephoto, but it did make the camera absolutely super for portrait work. Today, 100 to 120mm lenses for 6 × 6 are hardly telephotos, but they are wonderful optics for situations that require a slightly better perspective rendition. And again, they do make super portrait lenses.

Not all telephoto lenses are true telephotos; some are actually long-focus lenses. Optically speaking, the definition of a telephoto lens is

one where the design mandates a positive front and a negative rear lens-element configuration. Thus, the actual focal length of the lens is measured, not from the front element to the film plane, but from somewhere in front of the lens to the film plane. With a long-focus lens, the distance from the front element to the film plane would approximately equal the focal length. The advantage of a true telephoto is that the lens is physically shorter than the focal length it delivers. Today, long-focus lenses are not common, although they do appear in the much longer lenses called super-telephotos.

Telephoto lenses are thought of as optics that can magically bring distant objects close up; that is, produce perfect frame-filling images of distant subjects. If the lens is long enough and the environment suitable, they can do this. Unfortunately, we live in an atmospheric soup that is continually being stirred by the weather. The more distance between the lens and the subject, the worse the image will appear. Heat shimmer, diffusion and diffraction due to water vapor, smog, and dust particles all conspire to diminish the quality of the image. Also, telephotos must be held very steady in

order to produce optimum images. A good guide to selecting a shutter speed is to use the reciprocal of the focal length. For example, if you are using a 500mm lens, then the minimum handholdable shutter speed is 1/500 sec. Wherever possible, close the distance between the camera and the subject and steady the camera-lens combination on a solid object or an adequate tripod (not one of those spindly, reedy things that hikers are fond of carrying in a backpack). Keep the shutter speeds high and use a faster film than you normally would. Up to a certain point, the mass of the camera does

An ultra-wide fish-eye on the 645 format created this meditation on the forest's floor. The camera was set on full-automatic exposure. The brightness range of the film is exceeded in the area of bright sunlight. (Photograph by John Hamilton.)

work for you by resisting movement, but only at slow, handheld shutter speeds. The trick to good telephoto photography is to try to circumvent the elements that degrade image quality. Using a tripod is a good place to start.

Remember that telephoto lenses can be used in very closeup situations by inserting a short extension tube between the camera and the lens. This will turn even the most average telephoto into a useful closeup lens. The other option is to use a diopter, or closeup lens, in front of the telephoto. More of this is discussed in the section on closeup photography.

WIDE-ANGLE LENSES

An old gag says that to catch an elephant, all you need is a pair of binoculars, some tweezers, and a match box. You go out to where the elephants are, look through the wrong end of the binoculars, pick up the elephant with the tweezers, and put it in the matchbox. Optically speaking, this is just what wide-angle lenses do. Of course there are a couple of ways of doing it, each dependent on the type of medium-format camera you have in mind. If it is a nonreflex, rangefinder camera, then it doesn't matter if the rear lens element comes close to the film plane. However,

an SLR with a mirror that must swing out of the way before the shutter fires won't generally allow lens elements to extend far into the camera's throat and mirror box. Such a lens would work if you locked up the mirror, but that would defeat the point of an SLR.

The lens design that accommodates an SLR (and this is virtually any format SLR) is called retrofocus wide angle. If a nonretrofocus wide angle is used as a true wide-angle lens, then the rear nodal point of the lens falls within the lens itself. Nodal points are measured from front and rear. With a retrofocus wide-angle, the rear no-

This coyote was photographed with a F2.8 500mm mirror (catadioptric) lens designed for the Mamiya 645 system. Using mirror lenses requires a great deal of steadiness and care. Although they are relatively small and light, they are nevertheless super-telephoto optics. (Photograph by John Hamilton.)

dal point is back well beyond the physical length of the lens. In fact, the "non-true" tag probably comes from the fact that a retro wide angle is an "inverted telephoto," the old elephant catching trick. The advantage of a "true" wide-angle lens is that it maintains absolute precise correction across the focusing range. There are also special wide-angle cameras within the line of certain manufacturers, most notably the Hasselblad 903SWC with its remarkable Zeiss Biogon 38mm lens.

A retrofocus wide angle is definitely not at its best when used closeup; it is designed with corrections more suitable for subjects at infinity. This is not to say, though, that retrofocus wide-angles are poor lenses. In fact, in order to accommodate having all lenses function as universal optics, designers frequently add a "floating element" in the lenses. This is not as esoteric as it sounds. A correction element is included in the lens formula. This element moves, or floats, when the lens is focused. Its primary function is to ensure optimum image quality no matter where the lens is focused. Sometimes the floating element is driven by the focusing ring of the lens; sometimes a secondary ring is built into the lens barrel. The photographer sets this before or after focusing to engage the maximum corrections for a given distance.

Choosing a wide-angle lens should be governed by two criteria: what the photographic task is and the type of medium-format camera used. Understand that you may use either lens design, retro or nonretro, with complete confidence. But equally important, there is a difference between the two. Buying a wide-angle lens with the idea that it will "get it all in" is a common mistake. Using a wide-angle lens at infinity will indeed include quite a bit, but it won't always produce the spectacular images you expected. Wide-angle lenses produce their most striking images when used with very close foreground objects and sweeping the focus right back to infinity. But they can also produce the most exaggerated perspective distortion, which is why you usually don't use them for portraits. Naturally, to get this deep depth of field the photographer must know a bit about exploiting various lens apertures. Wide-angle lenses are very forgiving, but they can also dump you. I once ruefully discovered this when I forgot that the focusing scale on my wide-angle camera (fixed lens type) was calibrated in meters instead of feet. Five meters is not five feet, and no amount of depth-of-field forgave that blunder!

ZOOM LENSES

Zoom lenses are now readily available to the medium-format photographer. Note that lenses for medium-format cameras are usually two or three times larger than the equivalent focal length for 35mm. They are also heavier and, so far at least, are seldom very fast. So far, F5.2 appears to be the fastest zoom lens made, but even that changes as you zoom. Consider these factors carefully when thinking about buying a zoom lens. As a rough guide, zooms for 6 × 4.5 cameras are similar in mass and size to their 35mm counterparts. But when you move into 6 × 6 and larger, the weight and size increases almost exponentially. Having put the cons up front, note that the pros for zoom lenses are quite seductive. You simply carry fewer lenses!

Zooms actually divide into two types: the varifocal, which is not a true zoom but behaves like one 90 percent of the time; and the true zoom, which is parfocal, meaning it stays in focus when zoomed. The varifocal lens does zoom, but it doesn't stay in focus as you zoom. You have to refocus at each point you stop at through its ratio. It has been said that varifocal length lenses are superior optically to true zooms. While it may once have been so, it is doubtful that you could prove it today. Theoretically, a varifocal lens should cost a bit less because there is less mechanization inside the lens barrel.

It is the parfocal quality that makes a true zoom lens. The idea is that you zoom out to the maximum focal length, focus, and then zoom back to the desired focal length that fits your needs. The zoom, being truly parfocal, will stay in absolute focus at the desired position. And do they? For the most part, yes. If they don't it is usually because the photographer moved the focus ring when zooming. This brings us to another point. Should you buy a zoom lens with separate zooming and focusing rings, or should you buy the so called "one-touch" lens with its combined zoom and focus collar?

These portraits, taken with the Mamiya RZ67 and an F5.2 100-200mm zoom lens, illustrate the "before and after" effects of using the zoom. (Photographs by Butch Hodgson.)

Most of the zooms in the medium-format range are the twin-ring types. And as a rough guide, three prime lenses equal about two thirds the price of a zoom lens.

So what are zooms good for? Well there are zoom lenses that run from normal to telephoto and from telephoto to super telephoto. If your photography is mainly confined to these areas, then the zoom is a good universal lens for you. They work just as well with flash as they do with ambient light. Indeed, the modern zoom is in no way inferior to a prime lens optically. But when you require a wide-angle, you'll have to return to prime lenses. There are simply no zoom lenses that offer wide to ultra-wide capability. Zoom lenses, especially the shorter focal lengths, are ideal lenses for those involved in a lot of action photography. A motor-driven medium-format camera with a zoom and a good flash unit is a powerfully versatile tool. Any photographer using most any camera and trying to change lenses in the middle of a volatile crowd will attest to this.

PERSPECTIVE-CONTROL LENSES AND THE SCHEIMPFLUG EFFECT

I mentioned perspective-control (PC) lenses and the Scheimpflug effect earlier. These capabilities are readily available on many medium-format systems. But of course, the degree and type of vertical and horizontal shift varies with each individual camera. PC lenses allow the photographer to correct deviations or positioning of the image at the film plane, and

Notice the converging vertical lines in the top image, made without any perspective control. With the lens shifted up, the lines become parallel in the bottom image, but vignetting occurs along its top edge when the lens is shifted.

with some, it is possible to virtually "walk" the image almost off the focusing screen.

Vertical shift is perhaps the best known example of what a PC lens can do. For instance, when shooting architecture, the camera must be kept level to avoid converging vertical lines in the image. But making the film plane parallel to the subject though, the top of the building vanishes out of the top of the frame. By shifting the lens upwards and keeping it parallel to the film plane, the top of the building is kept in the frame, unwanted foreground is eliminated, and the image is corrected. Horizontal shift does much the same thing and is frequently useful for "getting" around unwanted foreground objects while keeping the camera parallel to the subject. Some nonreflex special cameras also have rudimentary shift capabilities. A classic is the Plaubel 69w Proshift whose lens panel will shift 13mm horizontally and 15mm vertically, and Linhof's Technorama PC 612 with a rigid lens panel that is offset vertically.

This Mamiya RZ67 is mounted with an F4.5 75mm perspective-control, or shift, lens. (Courtesy: Mamiya.)

This Rollei SL66 is shown with a dropped lens, otherwise known as a pulled front. (Courtesy: Rollei.)

If a camera has bellows, it may not need a shift-lens because of its Scheimpflug and shift capabilities. Classically, the Rolleiflex SL66 SE and SL66 X have enormous Scheimpflug capabilities built into the camera with its focusing bellows. Remember, the Scheimpflug effect is not the same thing as shift; rather, it is a method whereby depth of field for any given aperture is improved by tilting or angling the bellows in relation to the film plane. Imagine three objects laid on a table on a diagonal to the film plane of the camera. Because they are at a diagonal, only one can be sharp when initially focused. To get them all in focus, you have two options with a rigid-lens (nonbellows) focusing system. Depth of field is increased by stopping down as far as possible and hoping that the aperature is small enough to bring all three objects into adequate focus. However, using a bellows and the Scheimpflug principle, you can tilt or angle the lens so that it is parallel with the objects. Depth of field becomes less

important because, providing that the tilt or angle is adequate, all three objects now lie along the same plane of sharpness and will all be sharply focused.

Rollei also has a shift lens in its line-up, the PCS-Roleigon F4.5 75mm HFT. If you combine the PCS-Rolleigon with the Scheimpflug movements of the bellows on the SL66 SE and SL66 X, you have a system that can emulate most of the movements of a much larger, technical camera. The PCS-Rolleigon is somewhat unique in that it may be combined with a "ball/tilt" adaptor permitting 13 degrees of movement in any direction. Not only that, the PCS shift adaptor permits some view-camera lenses to be used as well. Note however, that just because a medium-format camera uses bellows for focusing doesn't mean it is capable of the Scheimpflug effect. A few are, but most aren't. The Fuji GX680 and the Rollei SL66 models are, but the Mamiya RB67 or RZ67 are not. On the other hand, most camera systems do feature a shift-lens in their lens line.

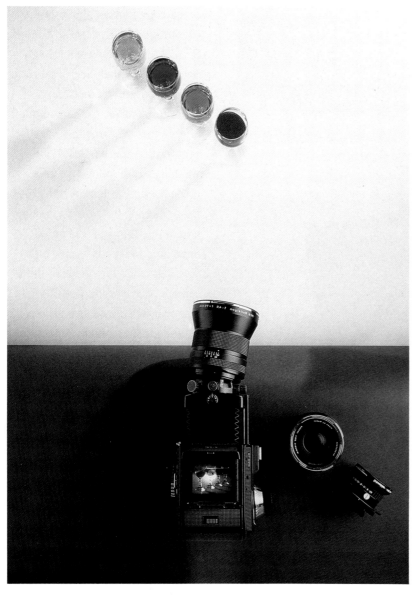

The Rollei SL66 on the far left is fitted with a PCS-Roleigon F.4.5 lens. Looking down at its viewing screen, you can see the setup of glasses that appear in the final image, pictured at left. This Rollei system enables you to use the Scheimpflug effect to bring all of a scene into sharp focus. (Courtesy: Rollei.)

FILM, PROCESSING, AND PROJECTION

When Hannibal Goodwin first coated a light-sensitive emulsion onto a transparent flexible base material, the direction in which emulsions would go was ordained. Today though, no matter how long the frame is, the negative almost never exceeds the conventional 6cm width. The spool-type loading of 6cm film has remained largely unchanged for over a hundred years, either a tribute to its original concept or a condemnation of film manufacturers' lack of vision. But 120 film is still the dominant size used by medium-format photographers. Two factors weigh in favor of this. First, the paper backing covers the entire length of the film and therefore helps prevent scratches as it goes through the camera. Secondly, 120 stainless-steel developing reels are easy to load, and the spirals are far enough apart to ensure good developing. The major disadvantage is that you only get between 8 and 12 shots before the film must be changed. This can be annoying in an important and fast-moving shoot. Around 1970, Kodak introduced 220 film that is nearly twice as long as 120 without the paper backing. A paper leader allows the film to be spooled to the first frame without any light hitting the film, and a paper trailer allows it to be removed without ruining any photographs.

Now there is 70mm film; it is loaded into the camera in a cassette, similar in style to the 35mm cassette. But 70mm hasn't found wide appeal in the more popular medium-format cameras. Still,

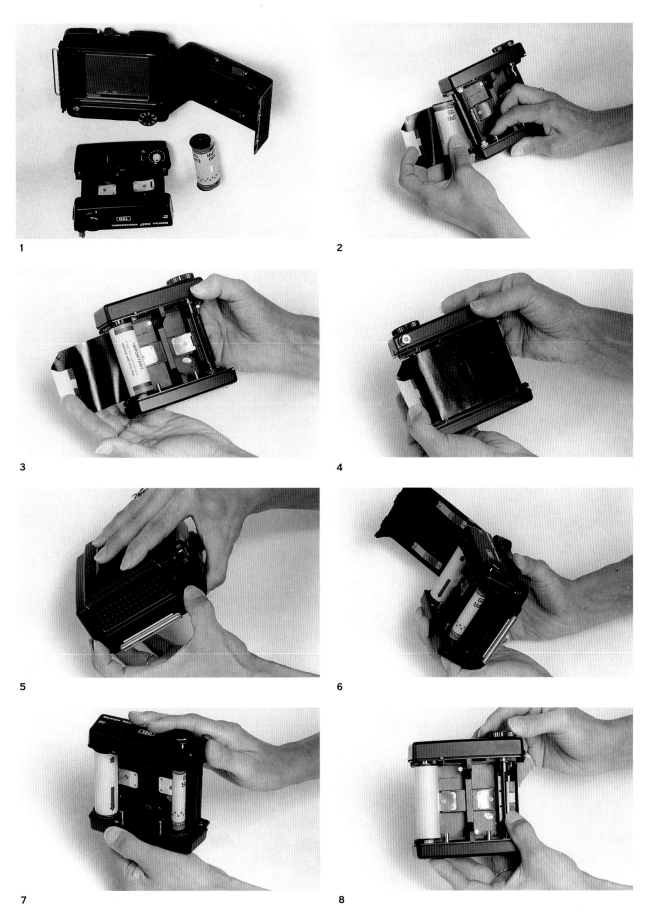

1

2

3

4

5

6

7

8

This series of photographs illustrates how to load and unload the Mamiya RZ67 magazine back made for 120 film.
(Photographs by Butch Hodgson.)

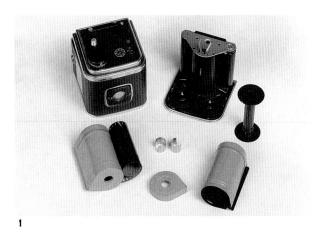

1

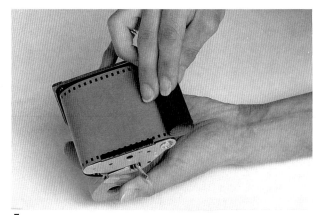

5

2

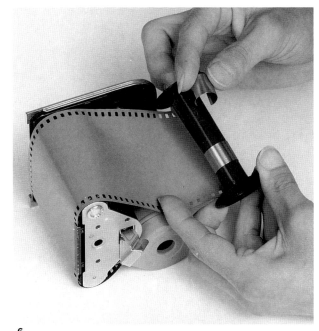

6

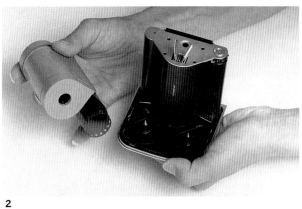

3

4

7

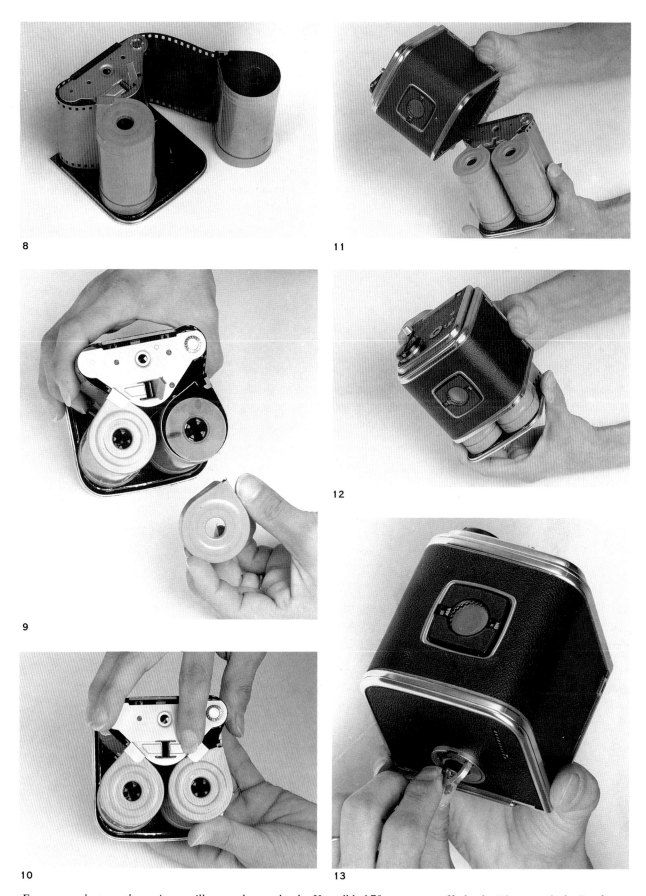

8

11

9

12

10

13

From top to bottom, these pictures illustrate how to load a Hasselblad 70mm cassette filmback. (Photographs by Butch Hodgson.)

there are obvious advantages to using sprocketed film in a cassette. Sprockets make drawing the film across the gate of the camera with a motorized advance system theoretically simpler. You can also load a lot more exposures into a film cassette than you can on the paper-backed or paper-leadered 120/220 film systems.

Finally, a very cogent argument for 6cm film in cassettes is that there is less chance of light leakage. On the 120/220 spool systems, loosely wrapped film can allow light to penetrate past the edge of the spool. Another point in favor of the cassettes is that they are easier to load and there is no paper band to remove or worry about getting dropped unseen into the gate of the camera. Many a good roll of pictures has been spoiled by having a piece of leader band print itself on some area of the negative. I always try to remove the band when the film is outside the camera rather than installing the roll onto the feed-side and then pulling the band off. I will admit though that it is probably safer to do it after the film is in the feed side spool to keep the roll from springing unwound. In any case, load with care, and unless you are very sure of your help or assistant, do it yourself.

Many medium-format cameras offer a 70mm back; specifically, Hasselblad, Rollei, and Linhof. The Texas Leica (which was just a big 70mm rangefinder camera) had a high degree of popularity among professional (particularly combat) photographers, but died anyway. But the 70mm cassette also has its

faults. Because it is not such a widely used system, film manufacturers don't offer the variety of emulsions available in spool form. Secondly, a cassette of 70mm film is quite bulky, and the cassette alone is expensive to manufacture and recycle as opposed to a plastic spool. So, for the foreseeable future at least, 120/220 paper back/leadered film is here to stay.

EMULSIONS AND FILM SPEED

Some photographers think that 35mm has the corner on emulsion technology, and that in medium format there is not the choice of film that 35mm users enjoy. This is simply not true. Take your pick; color or black and white, reversal or negative, slow, medium, or fast, film is there for the asking. Granted, some special films are a bit hard to come by—infrared film for example—but for the most part, medium-format film is equal to 35mm. As a rough rule of thumb, film speeds in medium format range from ISO 50 to 3200. Most of these emulsions have the latest advanced technology in manufacture, special grain, dye cloud formulations, and so on. All are designed to squeeze the maximum quality, resolution, saturation, speed, and stability from each film type.

There are so many films available that it is impractical to list them; but there are some generalities that may be useful as a user-guide. The general idea is that the slower the film (the lower its ISO rating), the higher its resolution, and the finer its grain. Because

grain technology and sensitivity are related, the ISO rating is reliable for what may be expected from a particular emulsion. Films in the ISO 50 to 100 range are considered to have fine grain and high resolution. ISO 200 to 400 films have medium grain and medium resolution. ISO 1000 to 3200 films range from moderately grainy to grainy, but their resolution still is remarkably high.

I used to hear photographers complain that there were no "Kodachrome"-type emulsions around for medium format. Never having been a Kodachrome fan I could scarcely have cared less. However, there is now a rollfilm by Kodak called Kodachrome and a rollfilm by Fuji called Velvia, the latter of which is an E-6 type process. In black and white there is also a wide selection of films available. Practically every film manufacturer—Agfa, Kodak, Fuji, and Ilford, to name a few— offers an excellent range of black-and-white films with the latest technologies, from T-grain (a way of achieving high resolution with low graininess) to color-negative-compatible processing films (C-41) such as the Ilford XP series. The choice of a particular film, be it black and white or color, is one that can only be made by the individual photographer and depends upon the requirements and the circumstances.

Also available today are some special black-and-white and color films. It should be mentioned that Polaroid offers a wide range of peel-apart, self-processing instant black-and-white and color films of

The new Fuji Velvia film has been widely acknowledged for its good color saturation and crisp grain. These two photographs, taken in strong midday light and at sunset, illustrate its versatility in different lighting conditions. (Photographs by Butch Hodgson.)

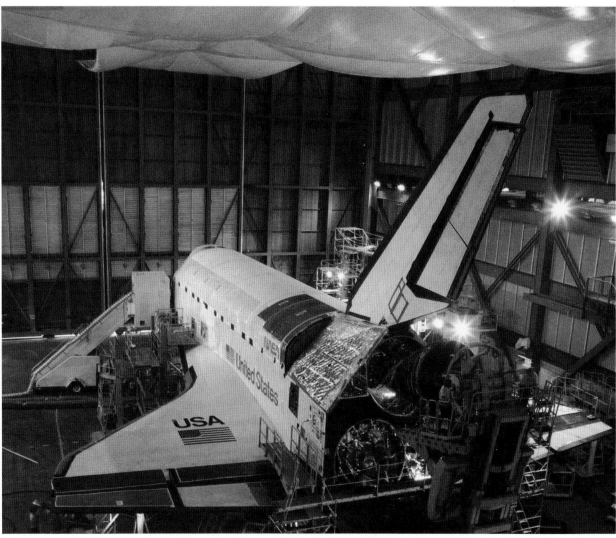

The space shuttle was being serviced inside the massive VAB at Kennedy Space Center when I shot it with Kodak Vericolor negative film. I chose this film to make it easier to correct for the frightful mix of lighting inside the building.

excellent speed and tonality. One might also consider infrared film or high-contrast copy film, designed for very high-resolution photocopying. There are also quite a number of films designed for various scientific applications such as ultra violet astronomical photography. The list is virtually endless, and perhaps the best advice is for you to contact the film manufacturer of your choice when trying to select film for special applications.

So what film should you use? Well, that is impossible to say.

I'm a confirmed color reversal film user, never having really found a need for color negative stock. It is all a question of personal style and needs; or, if you earn your living by photography (in which case you might disagree with many of these statements), the style and needs of the client. What film speed is best? Again, it depends on what you do. It is not much use loading a camera with ISO 50 Velvia if you intend to shoot mainly handheld under widely varying lighting conditions. And why go to the ultra-fast emulsions with their increased

grain if you don't have to? Macro and closeup photography (see page 124) obviously require the slower, high-resolution emulsions because they are shot with the camera adequately supported and illuminated. Macro in the field, tele-macro, and other esoteric techniques and environments don't always follow the rules; photographers must follow their instincts and make their own decisions.

INSTANT FILMS
Polaroid has become synonymous with instant-film technology, and

in America at least, they are virtually the sole suppliers of cameras and instant film. One of the rather exceptional advantages with medium format is that there is a special Polaroid-type film for practically every model of camera with interchangeable film backs. This is quite an achievement from an engineering standpoint and a rare incidence of accord in the photographic world.

Polaroid instant films for professional use are what are known as "peel-apart" systems. This process is actually a sandwich comprised of a negative emulsion using conventional silver halides, a receiving layer, and a pod of fast-acting chemicals in a viscous gel. The photographer shoots the picture and then pulls the packet out of the holder between a pair of heavy metal rollers. These burst the pod and distribute the processing gel between the emulsion and the receiving layer. The halides layer is processed and the balance of the chemical induces a migration of black silver grains onto the receiving sheet. This constitutes the final image, which is then "peeled" away from the rest of the packet. With these films there is no useable negative, and the print is basically the only one you get. However, Polaroid does offer one film that produces a high-fidelity black-and-white negative and an acceptable black-and-white print. Another advantage to Polaroid is that it has such a wide range of films available: color print, black-and-white high- and low-contrast, high-speed black and white, positive/negative black and white, overhead color transparency film, and a number of special emulsions ranging in speed from about ISO 75 to an astonishing ISO 20,000.

PROCESSING AND PROOFING

It is not my intention here to address the full arena of processing and general darkroom work. People often ask me. "Where do you process your film?" Generally I leave all my darkroom work for a good custom processing lab to handle. The truth is, it turns out to be more cost effective to have a lab do the work than to do it myself. I confess that I've never been a darkroom enthusiast—for me the rewards of photography are at the shooting level—but I have a lot of professional respect for skilled darkroom technicians. To each, however, his own.

Selecting a processing lab is not so simple. The only satisfactory way is by trial and error. I've had laboratories recommended to me by professional photographers of high repute, only to find that they do slipshod and dirty work when processing my films. A lot of it has to do with getting to know the owner, or at least with the people who are entrusted with your irreplaceable work. Make no mistake, all films are irreplaceable. They don't have to be shots of fleeting events; they can be as simple as that one gorgeous sunset over the ocean. No shot ever comes again. In fact, as a side note to this, if you see something, shoot it, even if you are sure that that same tree and that same rock will be there tomorrow, because the same subtle light that drew your attention to it in the first place will certainly be different when you return.

Try a lab several times until you are sure they can process your work. Don't give them your irreplaceable films first, second, or even third. When I do a shoot down at Cape Canaveral and I've spent several days in the miserable heat, humidity, and insect-laden climate of the Kennedy Space Center, waiting for the 18 seconds that comprise the significant part of a shuttle launch, entrusting my precious film to just anyone is not the way I like to go about it. Let them prove to you that they are worthy of your patronage. If they don't want to accommodate you, go elsewhere, there are plenty of labs hungry for business. Generally I like a lab where the owner is on the premises, so I can have instant access to him or her. Chain labs can be good and bad, depending on the luck of the draw. The bigger labs generally route you through to the second-in-command, or even someone's secretary before you locate the right person with whom to discuss your work. Remember, you want a custom film-processing lab, not the CEO of a multi-billion dollar corporation!

In cases where you are shooting with a film that is unfamiliar to a lab, make sure they understand what the material is that you are giving them. One operator, when presented with several rolls of Ilford black-and-white film, intended for processing in C-41 color chemistry, simply refused to

run it on the grounds that the lab didn't process black and white. Even with some of the newer Fuji film you have to be fairly explicit. An example is Velvia, new at the moment but possibly old by the time you read this. Although Velvia is an E6 processing film, it is picky and requires the lab to be on their toes concerning the pH level of the processing. This doesn't mean that the lab should automatically clean out their processing tanks and start fresh for your roll of film; that is not the point. If the film is E6 it should go through the same batch with hundreds of other E6 type processing films, no matter whose, and thus should come out fine at the other end.

Printing is another cause for concern. Custom printing should mean just that. You get what you pay for within the reasonable physical parameters of your negatives and their printing and processing. To a lot of labs, custom printing simply means that they will make print sizes other than those spat out by the automated printing systems installed. Custom printing to me means that I can talk to the printer, we can make diagrams, and I can suggest judicious cropping and burning in. In other words, the craftsman printer on their staff will do what you would do if you were printing your own material. Is this expensive? Yes, but compared to having your automobile fixed, custom printing is good value for the money if the printer you choose is good.

The same goes for duplicate slides. Most of my material is shot directly on color reversal film. While not always necessarily a work of art, it is something that won't appear again. I wasn't about to entrust my images of the demise of the space shuttle Challenger to anyone except the one man I deal with who makes my reproduction duplicates. Reproduction duplicates, or dupes, are just that, duplications of a high-enough standard that they may be sent to a separator for reproduction without loss in quality. Remember, the moment you copy anything the quality will start to decrease. Dupes are like everything else; the lab operator must know your taste in exposure and balance in order to give you what you like. The first time you have duplicates made from either slides or negatives is when you should set up the processing parameters. If you like the duplicate slightly denser, make sure the operator knows this. Try to supply a sample. Don't accept what he or she says you should have. Be specific about what you want. Remember, your reputation is on the line.

Developing and Printing Your Own Material. There is something to be said for processing and printing your own material. Processing 120 film is in many ways easier than 35mm except you need larger tanks and reels and a little more chemistry. Enlargers are available for 6 × 6, and they most likely use a 75mm lens. They can also accommodate the 6 × 4.5 negatives. However, if you're working with 6 × 7 or larger for-mats, then you must move up to the professional line of 4 × 5 enlargers at an increase in price.

From a speed-processing point of view, nothing beats your own in-house processor. Many of these systems are totally clean and simple to operate. All the user really has to do is to load the film into the system, fill it up with chemicals, and the machine does the rest. It is hard to get into trouble. These are easy systems to use, and there are a number of them available on the domestic market: Jobo, Beseler, and so on. They will, of course, process color, black and white, and even paper, depending upon how the unit is configured.

Medium-Format Slide Projection. There is no doubt that if medium format looks good on a light table, it is doubly impressive when projected. There are currently only three 6 × 6 fully automated medium-format projectors available: one from Hasselblad and two from Rollei. Hasselblad's PCP80 is a rotary, 80-slide magazine projector that features perspective control through the Zeiss lens. It also features such refinements as automatic lamp replacement should the primary lamp fail. The PCP80 is designed for professional audio-visual presentation use.

Rolleiflex offers two medium-format projectors: the Rolleivision 66 and Rolleivision 66 AV. The Rollei projectors are straight tray systems, and I leave the argument as to the virtues of the rotary versus the straight tray for those who wish to pursue it. From my point

of view, the rotary tray is "convenient" when it comes to large volumes of slides for an audiovisual presentation, especially for operations where the system has to run automatically. The Rollei system is also designed so that you

hook following trays (CM 77/30 type) onto the first tray for multi-tray presentations.

This aside, the Rolleivision projectors offer all the sophistication one would need for slide presentation. The Rolleivision 66 is

The Hasselblad PCP80 medium-format slide projector is designed for professional use. (Courtesy: Hasselblad.)

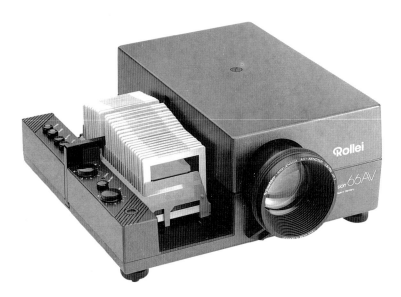

The Rollei 66AV projector is primarily used for 6 × 6 slides. (Courtesy: Rollei.)

designed around "semi-professional" applications, while the more "feature-loaded" 66AV is targeted at the professional audiovisual user. The Rolleivision 66AV features automatic lamp switchover, a built-in variable timer (3- to 45-second intervals between slides), autoreverse, auto/manual focus, lamp-intensity control, and opto-electronic sensing of user-applied reflector tabs. This system also permits slide sequences to be repeated. The 66AV may be run from external AV controller units and audio tape cues via the MD 216 universal interface. The lenses are all Schneider Xenotar or Heidosmats, including a Vario-Heidosmat.

For projection of slides larger than 6 × 6, there are not many options. One or two projectors permit the manual loading and projection of slides up to 6 × 12, but they are somewhat simplistic and tedious. Although the expensive 4 × 5 projectors are available, you can also transfer the images to videotape. There are a number of devices available that are designed as transfer systems. The advantage of videotape is that you can have a multimedia show on a single cassette, complete with sound, commentary, and effects track if you wish. However, one of the reasons for going to medium format in the first place is to get a maximum fidelity image, so except for the convenience of being able to send or show a client a set of slides without risking the originals, using videotape may not be much of an advantage.

Composing Medium-Format Photographs

Working with a medium-format camera is really no different from photography with a 35mm system except that the equipment is somewhat bulkier, and, so far at least, no one has brought autofocus to medium format. It follows then, that if the reader is "graduating" from 35mm, or has decided to "switch-hit" with the two formats, much of what he or she already knows about composition applies.

The Aesthetics of the "Square" Frame

Human vision is not square; the human eye "sees" in a rectangular format and is always aware of what goes on at the far edges. Motion in the peripheral areas can be detected quickly—"out of the corner of my eye." The off-center area of vision is somewhat better at perceiving dim objects; however, the central area of our vision is still the sharpest. So, if I drew a rectangle and dropped indicator marks in the middle of it to define a square, that masked area would be clearly in focus. The balance of the rectangular frame would be less sharp, peripheral, and thus less important.

Perception, or a sense of what looks right in the frame, is the name of the game. Composition can be learned to the degree that perception can be taught, as in Kim's game in "The Jungle Book." For those who never read Rudyard Kipling's classic tale, or don't remember it, Kim's game was designed to teach him the art of observation and retention. A

A beautiful interplay of light and shadow dramatizes this simple, elegant image. (Photograph by Ernst Wildi, Hasselblad.)

tray containing a number of different objects was covered with a cloth. When the cloth was removed for a few seconds, Kim was asked to look at the tray. Once the cloth was replaced, he was asked to name all the objects. It seems easy, but it's suprisingly difficult at first.

Above all, observation and retention require that you be aware of what is going on around you. In photographic terms, this means paying attention to the total area of the focusing screen. Examples of looking but not seeing bombard us every day on the television. One wonders where some camera people learned their art (for example, showing an anchorperson outside the White House with a flag pole seemingly growing out of her head, lamp shades for hats, and so on). In fact, learning to spot these compositional goofs on a TV screen is good training for the photographer's eye. Watch your backgrounds, and move left or right if you cannot move the subject. If moving is impossible, restrict the available depth of field to a minimum to keep background objects out of focus.

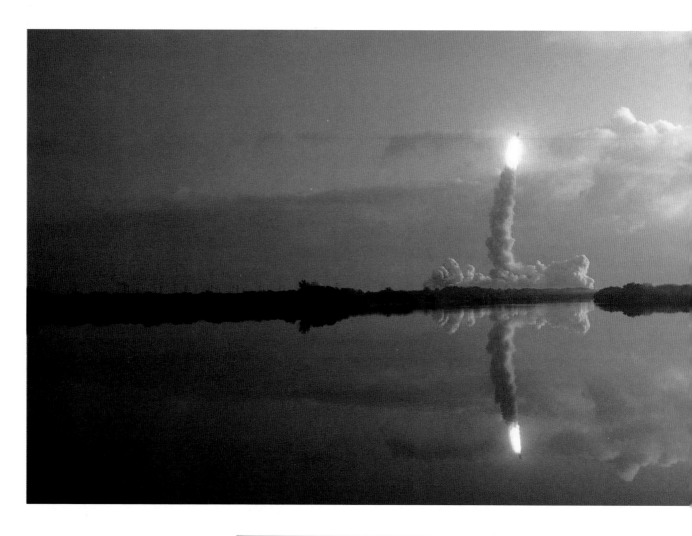

I shot this definitive photograph of NASA's space shuttle with a handheld Fuji G617, exposing the image for 1/250 sec. at f/22 without using a center filter. The picture now hangs in the press center at the Kennedy Space Center.

ASYMMETRY AND THE RULE OF THIRDS

There are a lot of books about the psychology of perception; the subject is quite beyond the scope of this book. No one really knows why the eye seems to prefer asymmetry in a picture; after all, people think they prefer a symmetrical world. It may be that we've "learned" to appreciate the dynamics of asymmetry because it moves our attention to a specific area of an image. Maybe it also works because we subconsciously find asymmetry disturbing, much the same way as atonality is jarring and gets our attention. Much of our preference is rooted in our own cultural and historical traditions. The images that get the most attention are generally those that break through our concepts of the established norm. A classic example of this was the furor created by Robert Mapplethorpe's photography. His images struck deep at the core of the public's sense of sensibility and decorum. Yet, for all of that, the man's images were impeccably executed. Creative minds have always been fair game for the dull and pedestrian to criticize and fear. If this is true in painting and music, it is also certainly true today in photography.

The same may be said of images brought back to us from areas of human conflict. The two photographs that burn in my mind from Vietnam are not the tons of napalm falling onto abstract jungle clearings, but of a little naked girl running terrified down a road as napalm lands behind her in the distance; or the frightful, split-second image of a Vietnamese general executing a suspected Vietcong prisoner. But for all the violent reporting that the camera is capable of, it can also show the calm and beautiful images of the universe around us. When those images are comprised of balanced, carefully composed elements in the scene, something within us responds and says, ''that's a good picture.''

On the whole, asymmetry in images is far more powerful, and in most instances, aesthetically pleasing than symmetrical composition. According to classical thought, the most harmonious composition is one that breaks up the image into thirds, placing the primary subject somewhere off-center in the image area. Unless you have a very good reason for doing so, don't split the picture into two equal halves. And, because everything has its counter, if you have good reason for doing so, split the picture into exact halves! This you can do when shooting mirror-image reflections such as the shuttle launch, shot on 6 × 17 format, shown above.

Leonardo da Vinci wrote about the Rule of Thirds in the year 1500. From then until now, the rule is still basically the same. If the artist divides the square, or rectangle, into thirds both ways and then puts the dominant center of interest at this intersection, the appeal of the composition is enhanced. Of course, there are times when the law of thirds, moving the subject off-center and so forth, is inappropriate. I usually make very

Placing the subject slightly left of center allows her shadow to balance the composition by adding weight to the right side of the picture. (Photograph by Lucille Khornak.)

sure that any powerful, newsworthy action is well and safely surrounded by enough frame. Similarly, where there is a single object and no distracting background, centering the subject works well because its position forces the viewer's attention onto the subject alone. If you shift a subject to one side, or even the top or bottom of the image area, then the dominant element might need to be balanced by a secondary element.

Balance is the essence. The simplest way to achieve good composition is to move the image around in the finder or focusing screen until you arrive at an arrangement that satisfies your inner feeling about the subject. If you like compositions with the subject right in the middle of the frame, then that is your idea of correct composition, and as long as you are prepared to defend your artistic choice, you are correct.

LEAD-IN, LEAD-OUT EFFECTS

Imagine that you're shooting a portrait of someone. Composition can generally be balanced according to the rule of thirds, but you

Centering the subject is an equally viable choice in the square, symmetrical frame offered by a 6 × 6 format. (Photograph by Lucille Khornak.)

should be careful where you cut the subject off. You can certainly ''crowd'' the subject in the frame, but any amputations invariably lead the eye out of the image area. And besides being rather ugly, it is just bad form! Remember that the eye is attracted to bright, or moving, subjects. If a television set is on in a dim room, the movement, brightness, and of course, the

color, will attract the eye. You get the same effect in a still image. It is not necessarily wrong to place bright objects to the side or edge of the image area, but be aware of what it will do visually.

Color is powerful. A general rule of thumb is that bright colors move forward, or come towards you, and darker colors recede. Working in black and white,

colors are translated into tones, and the effect is the same. Of course, it depends on how you wish the primary subject to appear: moving towards the viewer or moving away. If you have a bright subject occupying, say, a quarter of the picture area but set somewhat back in an overall dark image, the eye will search for the brightest part of the image. Thus,

This eerie picture was one of the last taken of the doomed Challenger *space craft. I saw this strange lighting upon returning from setting up my remote cameras. With a Rolleiflex 6006 Mk2 and a 250mm Tessar lens, I shot it handheld at 1/125 sec at f/5.6 on Fuji color negative film.*

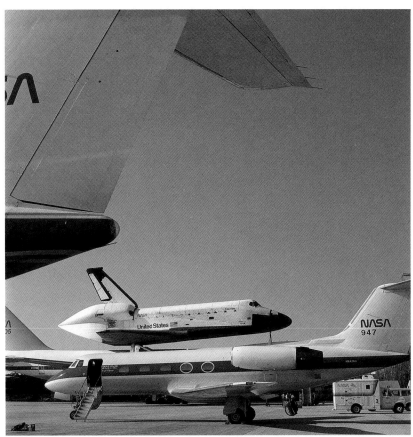

If you can't get close enough, use the foreground and frame the image. I took this photograph of the space shuttle "piggybacking" on another plane with a Rolleiflex 6006 Mk2 and an 80mm Planar lens.

you can control how the viewer will "see" your image by exploiting this apparent momentum.

Generally speaking, horizontal lines are considered static; that is, they tend not to move the eye anywhere. Diagonal lines, however, are thought of as being dynamic. If you draw two lines diagonally to converge at a point in an image, the eye will move along them to that point. A real demonstration of the power of diagonals may be seen with wide-field images (rectangular format) if you accidentally tilt the frame! The error can be seen immediately and, unless done for deliberate effect and emphasis, is inexcusable.

RECTANGULAR MEDIUM FORMATS

The longer the format gets, the more dramatic the shots tend to become. This isn't to say that moving to 6 × 12 or 6 × 17 will automatically improve your photography, but often the wider the field, the more interesting the image. One major problem with the "longer" medium formats lies in the fact that many of these cameras don't offer flexibility in lens focal lengths. If they do, returns are diminished because of the increase in size and weight of the equipment. Panoramic formats offer a wonderful, eye-consuming sweep of image. The basic laws of com-

position still hold true of course, but wider formats give the photographer a bigger canvas on which to arrange the elements of the picture. What has to be considered is that wide images don't exactly emulate what the human eye sees. If it is true that our vision tends to concentrate towards the center of our field of view, then the wide-field camera sees all things with equal acuity within its own angle of view. No matter how skillful the photographer is in placing elements of the picture at different and varying distances in the shot, a flat piece of film is still a flat piece of film. This makes the placement of elements in the panoramic image area even more critical in order to exploit the beauty of the wide field.

A common misconception is that a wide-angle lens can "get everything in." In some ways this is true, because the lens does indeed reduce the size of the elements in the field of view, thereby increasing the size of the area that is seen. But simply pointing a wide-angle lens or camera at a scene and blazing away is poor technique. Diagonals and the leading line must be considered with this type of equipment. Emphasis and style are created by having certain important elements of the image as close to the camera as the focus will allow. The resulting picture then contains elements that lead the eye in any direction the photographer wishes, creating a pseudo three-dimensionality in the final image.

I shot this wide-field image of astronomical streaks by leaving the shutter open for over an hour. The broad white band is the full moon, the narrower white line the planet Jupiter.

Using a Linhof Technorama 612PC camera and a 2X Heliopan center filter, I exposed this dawn landscape on Fuji Velvia film.

COMPOSING PORTRAITS

Above all, when shooting portraits, make sure the eyes are sharp even if nothing else is. And be careful not to distort the image by moving the lens too close to the subject, especially if the lens is wide angle. The longer the focal length of the lens, the more the image's perspective will be jammed together or compressed. This effect is excellent for portraiture because it is usually flattering to the human face. This is also a useful effect when compressing objects at different distances in the scene, but it depends on how much space exists between the objects in real life as well as how much depth of field is available.

In both of these portraits, the eyes are the focal points of the pictures. Distortion was prevented by shooting with a long lens at a safe distance from the subjects. (Photographs by Lucille Khornak. Above, courtesy: Look of Love Wigs. Right, courtesy: Renaissance Eye Wear.)

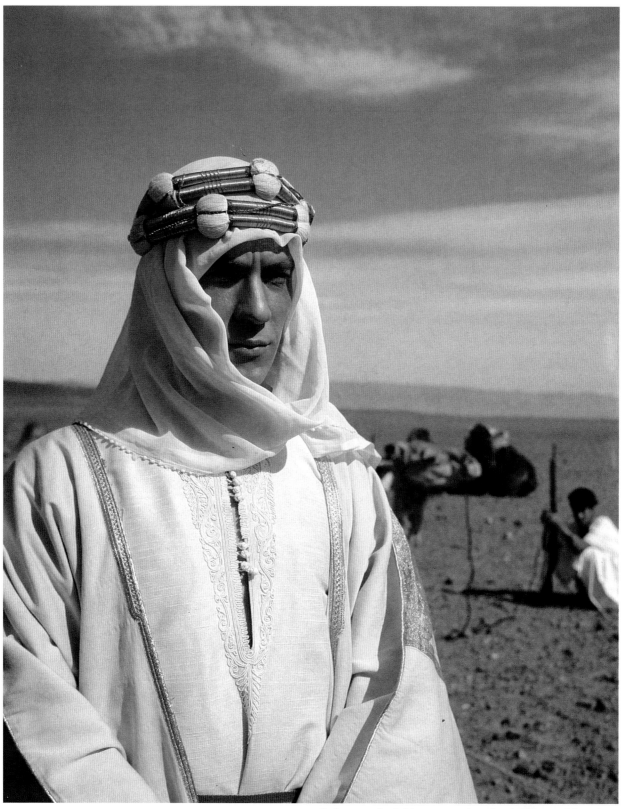

I photographed this actor on location in Zagora, Morocco, for the BBC's production of "Ross," using a Rapid Koni Omega 6 × 7 rangefinder camera. This could be considered an environmental portrait because the surrounding elements reflect both the landscape and the character.

When you move into 6 × 12 and 6 × 17 images, you generally work with a wide-angle lens; or at best, in the instance of the Linhof Technar, with three wide-angle lenses of varying focal lengths. It could be argued that you can't use a wide-field camera for portraits, but you can, if you are careful. Naturally, wide-angle lenses produce extreme distortions of subjects near to the lens. Of course, perspective distortion is a fact of life with any lens. The longer the focal length, the greater the perspective compression, and the less apparent the image distortion. However, when you are trying to make a shot of someone and wish to include a wide expanse of background, wide angles are often the only way to go.

The 6 × 7 format was excellent for centering this portrait of a mime performing for a crowd. (Photograph by Butch Hodgson.)

A gentle wide-field seascape depended on my using a low angle to emphasize the scale effect. I composed it with a Fuji G617 and exposed it on Fujichrome 100.

EXPOSURE AND LIGHTING

The business of correctly exposing your film in the camera is both an art and a science. When an automatic-exposure (AE) metering system is built into the camera, the photographer simply points the camera at the scene and usually presses the shutter button half-way down to activate the meter. Built-in metering systems may be through-the-lens (TTL); that is, the meter cell may be located in the lens to see what the lens sees. It could also be mounted beside the lens, usually adjacent to the view-finder window.

BUILT-IN METERING IN MEDIUM FORMAT

As a rule, most built-in metering systems are center-weighted; that is, the meter is designed to "see" more towards the center (and often bottom) of the image area. The logic behind this is that the primary subject is often placed in the center of the frame, so the meter should be biased towards that area. Is this true? Ninety percent of the time it is, and this system works quite well. No matter how the professional nabobs argue against this arrangement, it keeps a great deal of photographers out of trouble. (I can already see some of my professional colleagues reaching for their cudgels!) The meter is supposedly "loaded" towards the bottom of the frame area to avoid inflated readings from the sky (as, according to the law of thirds, it generally occupies about one- to two-thirds of the frame).

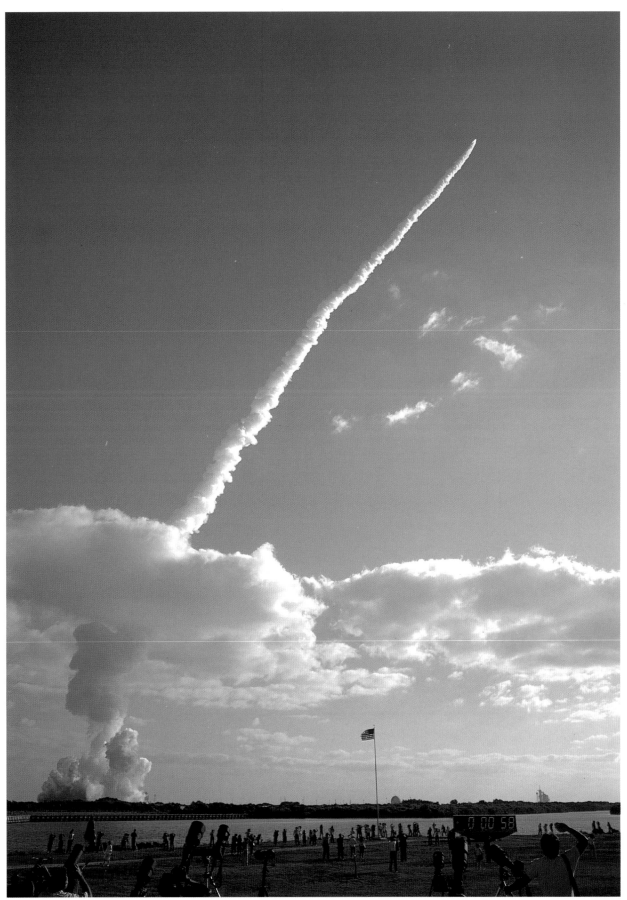

I took this picture of the launch of the Hubble Space Telescope with the Fuji 6 X 4.5 Fujica Wide. The metering for this shot was built-in and coupled to the lens. The exposure was 1/250 sec. at f/11 using Fuji Velvia 120 film.

Interestingly enough, it doesn't seem to matter to the meter if the camera is rotated from a horizontal to a vertical shooting mode. Of course there is little point rotating a square-format camera, because 6 × 6 is still 6 × 6 even if you stand the camera on its head. Frequently, though, a rectangular format will be used in a vertical mode. Unless the camera is endowed with a gravity switch to tell the metering system that it has just been turned on its side and to adjust accordingly, or if the system has some elaborate algorithms included for compensation, you might expect the readings to be "false." In practice they rarely are because center-weighting is primarily that, with little regard for camera orientation.

When the meter is built into the camera, more than one type of metering pattern may be available. Center-weighted metering can be used for normally lit scenes. Spot metering is for more selective readings. Partial metering will read a single subject in the scene and average that.

CENTER-WEIGHTED METERING

SPOT METERING

PARTIAL METERING

Generally meters try to "read" off an area that is in the region of 18-percent grey reflectance, the optimum exposure balance point for most films. To this end, most metering systems integrate the readings and average out the results to this approximate value. Most programmed meters are quite deft at evaluating the exposure. Usually however, you should intervene and "tell" the meter what you really want to do. The simplest and often the fastest way approach is to use the "meter-lock" approach. Take for example, a gorgeous sunset over a grey and tranquil sea, a simple study in extremes. Where do you "point" the meter? At the sun, at the sky, or at the grey mysterious water? If you point it at the sun, the exposure will generally be favorable for that part of the scene. But what happens to the rest of the image? That depends on how big the sun is in the scene, which in turn depends upon the focal length of the lens mounted on the camera. Remember, the meter is most likely center-weighted and will try to bring in a compromise reading for the sun and the rest of the scene. The sun will not be quite that intense color you remember, and the sea will not be anything like Homer's poetic "wine dark" description. So you must decide which is more important in your image.

Generally speaking, the slower the film, especially color, the narrower the exposure latitude; that is, the film's ability to handle the bright and dark ends of the brightness range. Experience shows that the brighter areas of an image are

favored by using slide film, and the darker areas by using color or black-and-white negative film. To put it another way, with slide film shoot for the highlights and let the shadows look after themselves, and when using negative film, shoot for the shadows and let the highlights take care of themselves. This still works remarkably well, especially with built-in or TTL meter systems.

After some diversion, this returns us to the practice of meter-lock, a kind of manual control in the automatic mode. Point the camera at the area you are most interested in, touch the shutter button to activate the meter, take your reading, and set the meter-lock. After the exposure is set, recompose the image in the viewfinder, and release the shutter. If there is a specific subject, or tone that you are interested in, meter that, and lock in that exposure.

One way to ensure the right exposure is to bracket the picture; that is, take three pictures of the same identical scene at slightly different exposure settings. If this sounds wasteful of film, consider that film is the least expensive part of the process, and the plan is to come home with perfect images. More professional photographers bracket than honestly admit it. It is not only a question of nailing down one image; it is also a question of having a set of differently exposed options on the light table. I often shoot a two-picture bracket, one shot on the metered exposure and the other about two-thirds under. Frequently the slightly denser, richer, and theoretically underex-

Bracketing exposures is a simple process that should be used for all your important shots. Not only will you be assured of getting a good exposure, you'll also then have a choice between darker and lighter images. (Photographs by Butch Hodgson.)

posed image is preferable. (Indeed, most experienced photographers add a slight underexposure bias by rating the ISO slightly faster than stated on the box, say ISO 100 instead of ISO 80 and so on. Bracketing is simply an extension of this technique.) But experi-

ment first, shoot test rolls, find out what the film likes, and of course, what you prefer.

The easiest way to shoot a fast three-stop bracket—one frame at the metered exposure, one a stop under, and one a stop over—is to aim the camera at the subject, note

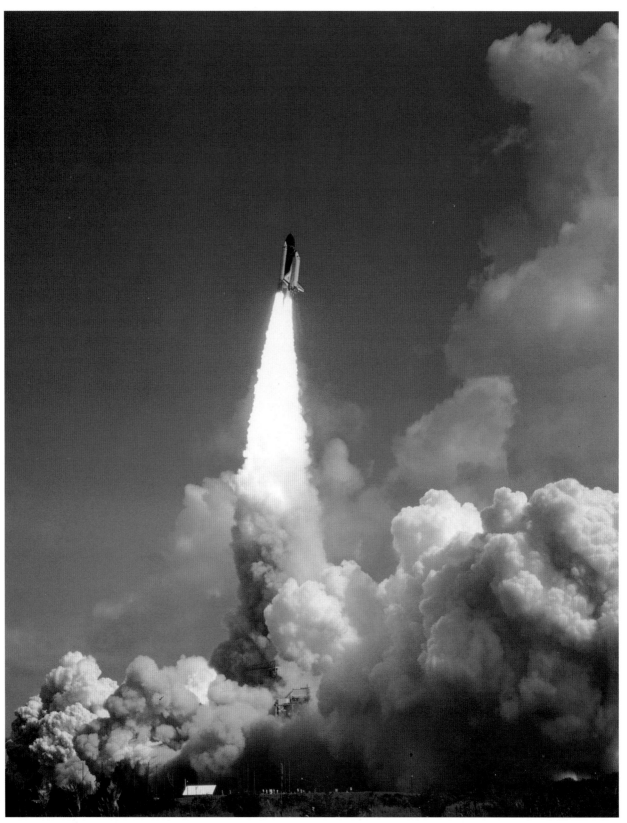

This shuttle launch shot was made with one of my remote cameras: a Rolleiflex 6006 Mk2 and an F2.8 80mm Planar lens. The shutter speed was 1/250 sec., but the lens aperture remains unknown as always because the camera was set on autoexposure plus 1 stop. A sound-activated trigger was used to start the camera.

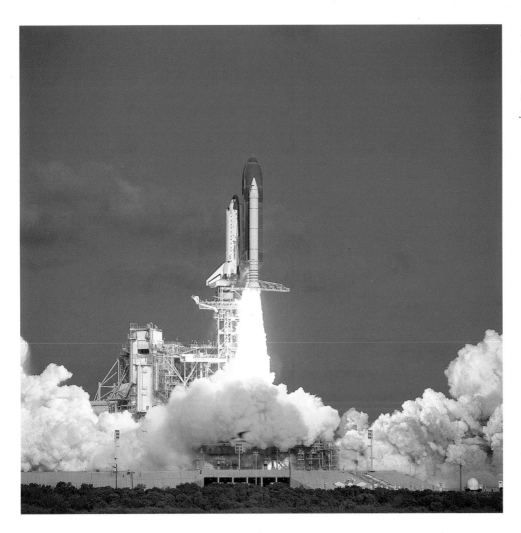

I also made this remote camera image with the Rolleiflex 6006 Mk2, this time on Fuji Velvia ISO 50 film.

the normal exposure reading, and take the shot. Now aim the camera at an area that will cause the meter to read one stop less exposure, lock the meter, recompose and take the picture. Now do it the other way. This kind of bracketing is quick and efficient. Some cameras have an autobias mode built into the TTL metering system. This ability is rather common in 35mm SLRs but quite innovative in medium-format cameras. The Rolleiflex 6008 is such a camera. You may program the meter to shoot multiple-stop brackets. Each time you take a picture, the camera will change the exposure to conform to your programmed instructions.

Under certain circumstances it is best to let the camera monitor the exposure, even though the average metered exposure reading would be in error. A good example is with my remote photography of the space shuttle launches at Cape Canaveral where I customarily set out several cameras in the swamps surrounding the shuttle. Obviously I don't sit out there with an eager finger on the shutter release waiting for the moment NASA lights the rocket boosters. A sound sensor trigger is connected to the camera, and the whole process is automatic. My own cameras are Rolleiflex 6006 Mk2's with automatic TTL exposure systems. But here is the prob-

lem: the remote systems are set about 24 hours prior to the launch. Exposure readings taken at the time of the set-up may not be valid at launch time. So I set the cameras on AE metering. When the shuttle fires its main engines, the sound wakes up the cameras and they begin taking pictures. A couple seconds later, the solid boosters fire, and the shuttle launches. The main engines are scarcely bright at all, and if that were all one had to contend with, then standard center-weighted daylight exposure would be fine. But when the boosters kick in, it gets a lot brighter a lot faster, and the brightness is confined fairly close to the central area of the image. Left to

itself the AE system would immediately reduce the exposure to make sure that the solid booster flames were correctly exposed. Unfortunately this would under expose the shuttle itself, and the surrounding area of the image.

So what is the solution? I set the AE metering system for one stop higher than the ambient daylight reading. Actually I'm just deceiving the meter into believing that the film is slower than it really is. For instance, if it were an ISO 100 film, I would set the meter for ISO 50. The light of the boosters would inflate the exposure reading and set the stop accordingly, but because exposure bias had been applied, the overall scene would come out correctly exposed. What about the first two or three frames before the solids ignite? Well, those of course would be overexposed, but they are not the images I'm looking for anyway.

HANDHELD EXPOSURE METERS

There are two types of handheld exposure meters: direct-light reading meters that read the light reflected off the subject, and incident-light meters that read the light falling directly on the subject. Spot meters fall into the former category, and spot reading options are built into many cameras' AE metering systems.

Reflected-Light Meter. The reflected-light meter is basically the same as the AE TTL metering systems found in cameras. It reads a fairly broad area and integrates or averages the light bouncing off the subject. It will, of course, read a specific area if it is confined to that specific area. This is known as subjective metering: moving the meter close to an area of a single tone to only read that light. Reading off one's hand or an 18-percent card is a good example. Bear in mind that when you do meter this way, the area that is lit should be lit at the same angle and from the same light source as the subject, otherwise substitute readings are invalid. Several readings should be taken, depending upon what is required for the exposure.

Spot Meters. As accurate as spot metering is, it does take some practice to work out a good technique. The problem, or the beauty of it, is that the readings can vary within several *f*-stops depending on where you point it. The irony is that a spot meter is "correct" when it is pointed at an object that reflects 18 percent of the light. A blue sky reflects about 18 percent, and so does your hand, or a special 18-percent reflectance card, which is all very well if the conditions are good, but that is often not the case. The following guide generally works accurately for a spot meter. If you're shooting slide film, point the meter's spot (this spot, or spot graticule, is the area defined by the frame in the meter telescope; it can range from about 1 to about 12 degrees for cameras with built-in metering systems) at the highlights. Obviously, unless you're shooting the prime illuminator, the sun or a lamp, don't point the meter at these. In the case of negative material, point the meter's spot at the darkest area in which you want detail. Now several spot meters offer the ability to "add-up," or integrate, a number of readings. It is feasible to meter several areas of the scene and then take the averaged value of those readings. This technique differs from average metering in that you, not the meter, define the parameters that the meter will read and integrate.

Where the spot meter really scores is in long-range metering of small or distant subjects. The one-percent reading area of the Minolta Spot Meter F, for example, allows a very tight reading on an object the size of the space shuttle at a range of about 4 miles! The Minolta, like all spot meters, is battery powered. Not only will it read ambient light, but it may also be switched to a flash mode. It features a number of functions designed to automate spot reading such as memory, shadow reading, average reading, highlight reading, recall for the memory, progressive increase/decrease ISO settings, and progressive increase/decrease settings for shutter speeds and lens apertures. The data is displayed on a large LCD panel on the side of the meter, and there is also an LCD display that may be optionally illuminated inside the finder. Pressing the S, A, or H button after taking one or more readings will cause the meter to display the shadow value, the average value, or the highlight values of the reading(s).

The Minolta Spot Meter F takes reflected-light readings. (Courtesy: Minolta.)

The Minolta Flash Meter IV is both a flash and an ambient-light meter. (Courtesy: Minolta.)

Incident-Light Meters. The incident-light exposure meter system is probably the simplest to use, and is actually quite ingenious. Here the meter is taken to the subject and aimed directly back towards the camera. A translucent dome integrates all the light falling upon it from the direction of the camera and converts it into an 18-percent reflectance reading. Incident-light metering is widely used, particularly when flash is the light source. Again, some judicious selection of what you want the meter to see is in order for precise metering, and remember that the meter is supplying you with an integrated 18-percent reading that you may want to modify depending upon the tone of the subject. One of the classic "switch-hitting" meters, but still basically an incident-light-type meter, is the Minolta Flash Meter IV. It is both a flash and an ambient-light meter and will work connected via a cord to the flash unit. Additionally the Flash Meter IV has a rather unique optional accessory with which it can communicate with the camera via a built-in infrared transmitter.

Meters, either built into the camera or handheld, do not absolve the photographer from thinking about exposure. When all is said and done, the old sunny-sixteen rule works very well too. Setting the stop by eye is a matter of experience, but if you just remember that the film speed is used as the reciprocal of the shutter speed when the lens aperture is set at $f/16$ in bright sunlight, you can't stray too far from success!

COLOR TEMPERATURE

Here, I must digress slightly and discuss the very medium that photography is based on—light. Generally speaking, daylight color film is balanced to handle noon sunlight, or about 5600 degrees Kelvin, which is also what electronic flash tubes and even blue-coated flash bulbs emit. For tungsten lamps, color reversal film is balanced at 3200K in order to compensate for the lack of blue in the light source. Any deviation from these values will be reflected in the way the film "sees" the color. Although the eye can "see" the broader differences in color temperature, most people ignore it. As a result, they tell the film processor and printer that the color of the final slides or prints is all wrong. Usually the lab will try to balance material received for printing to a nominal value unless you tell them not to do this. From the craftman's point of view, it is necessary to get the exposure and the color balance as close as possible to what you visualized when shooting. This may involve using color balancing filters that are designed to correct the deficiencies, or excesses, in the color temperature. You might also want to use a color meter. Color-temperature meters literally evaluate the Kelvin of the light, displaying it on the dial. In the box below appears a table of color temperature values in degrees Kelvin for various types of light.

TYPE OF LIGHT	KELVIN/COLOR TEMPERATURE
Mean noon sun	5600 K
Shade with blue sky	12,500 K
Overcast	6250 K
Electronic Flash	56/900 K
Halogen lamps	3500 K
Photoflood	3450 K
Average household lamps	2900 K
Candlelight	1850 K

This table gives an idea of the variations in the color temperature of light under different circumstances. The importance of correcting the "deficiencies" rests with the photographer. If you shoot product pictures where the subject must appear exactly as it is in life—or as the art director imagines it to be—then correction to the light should be applied. On the other hand, correcting out the soft evening light bathing a landscape would be nothing short of barbarism.

USING AVAILABLE LIGHT

The angle of the light, that is, the way it shines on the subject, determines the power and impact of the shot. Even the most ordinary scene can look beautiful when lit by early-morning or late-afternoon oblique light, every detail is picked up and the light gives the scene texture. Light, in a word, transforms. Each effect is even given specific (and sometimes elaborate) names: Rembrandt lighting for soft, golden effects; or "contra-jour," which is an elaborate way of saying "against the light" or backlighting. Artists and photographers also work with the "plasticity" of light, and even, "chiaroscuro!" But whichever way you cut it, lighting can be divided into three basic types: front-, side-, and backlighting.

Frontlighting. This angle of light suggests the old rule "put the sun over your shoulder and shoot." Although such lighting is "safe," it is generally quite flat and unimpressive unless there is some other phenomena to accentuate the shot. For example, if a low-angle sun is shining from behind you through a low bank of clouds, a heavy cloud layer in front of the camera can be very dramatic. While it is still frontlighting, it creates a contrast between the subjects in the foreground and the backdrop of clouds. Such lighting is generally very fleeting, so be ready. The rule of thumb is to avoid flat lighting unless you happen to either like it or it enhances the shot's effect. Ironically, color film loves flat lighting, because the illumination usually doesn't exceed the brightness range of the film.

Hanging over Lower Manhattan in the Fuji Blimp, I took this shot with a Fuji G617 on Fujichrome 100.

Heavy sidelighting adds dimensionality to this picture. The exposure had to account for the bright sunlight so as not to lose any detail in the trees. (Photograph by Ernst Wildi, Hasselblad.)

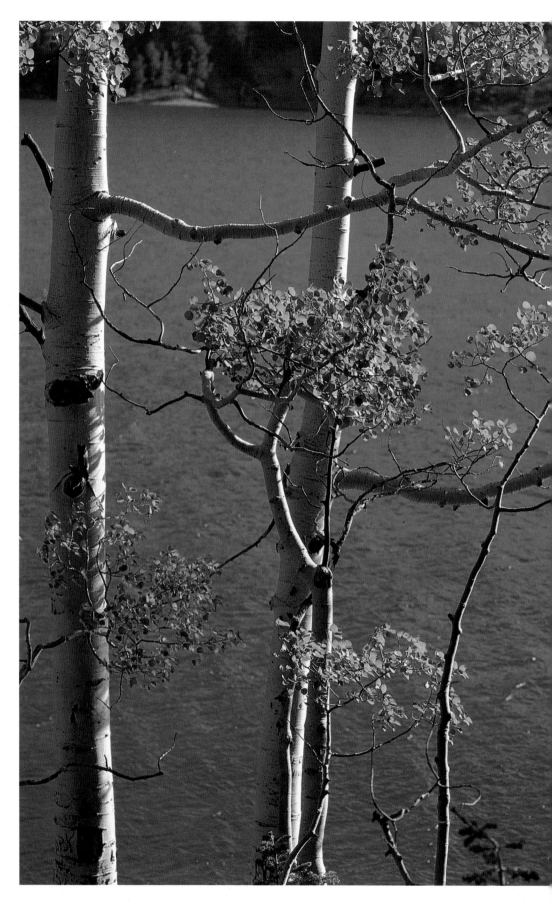

Sidelighting brings texture alive, as the masonry and wooden siding of this old house display. (Photograph by Butch Hodgson.)

Sidelighting. Looked at from a photographic standpoint, sidelighting produces very effective images with excellent contrasts and textures. The more severe the sidelight, the more enhanced the effect and the ratios between light and shadow areas. Sidelighting will introduce some dimensionality in what is actually a flat-image translation of a three-dimensional reality. Because it increases the contrast between adjacent areas, it will also appear to ''sharpen'' the image. But be careful of this ef-

fect, for while it can be very dramatic, it can also deceive. Make certain that the image is indeed sharply focused on the viewfinder's focusing screen, and ensure that the depth of field is adequate for the image you had in mind.

Remember that you might want to enlarge the image, and the larger you go, the more that any errors will be revealed. Sidelighting also, by its nature, increases the differential between light and dark. If that ratio is beyond the brightness range of the film, the

highlights may burn out, or the shadows plug up. Carefully consider your exposure. Despite the glory of the effect of side light, you may have to use a reflector or even a fill-flash to soften harsh shadows, especially in portraits.

Backlighting. Sometimes known as "contra-jour," or "into the light," backlighting is powerfully effective because it picks up textural detail and usually halos everything in a nimbus of light. This type of lighting is quite tricky to work with and not easy to meter. Backlighting is largely an "effect" light because everything seen from the camera's point of view—that is, facing you—will be shadowed. Additional lighting is sometimes needed to illuminate the front of the subject. Synchro-sunlight, or fill-flash with backlighting, is the most common application. Turn your subject with his or her back to the bright ambient light and then light the subject with a front or semi-side flash. This gives you a portrait

Manhattan's skyline at sunset made a perfect subject for backlighting, especially since the city's lights kept its buildings from becoming merely silhouettes. (Photograph by Lucille Khornak.)

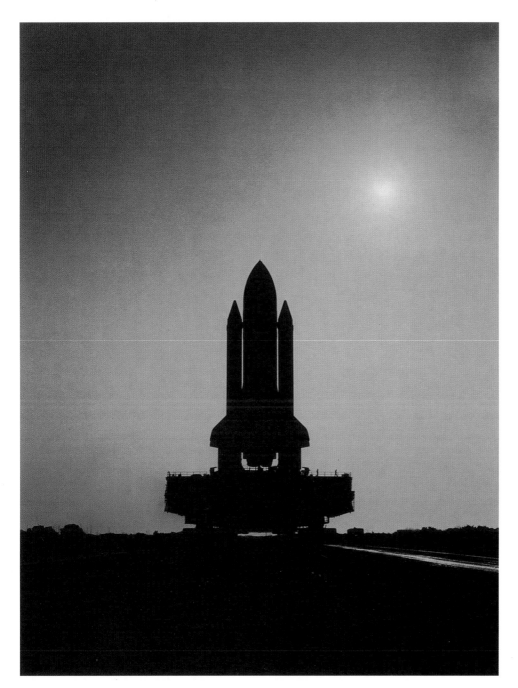

Exposed only for the backlighting in the sky, this dramatic image of the space shuttle on the crawlerway becomes like an icon for the technology of the space program. (Photograph by John Chakeres.)

where the eyes are not screwed up against the glare and the ambient light acts as a "kicker." The old Hollywood three-light setup for glamour portraits uses this principle. The main light illuminating the subject is fairly flat and soft, a second lamp is aimed in from a side angle in order to enhance detail, and a third lamp is placed above and behind the subject and "kicks" the highlights into the hair. It is a very simple setup, easy to use, and very amenable to electronic-flash work in a controlled studio environment.

One small point concerning the use of backlighting and the optics of the camera: Remember that any lens aimed too close to a light source will produce some flare in the image. The more glass elements within the lens (especially zoom lenses), the greater the induced flare will be. The solution is to aim off the light so that it doesn't strike the lens directly (a lens shade can help), or, if you can't get rid of the flare, utilize it as an element of the image.

THE ELECTRONIC FLASH AND FORMAT

That abundant and portable light source, the electronic flash unit, is now so ubiquitous to photographic applications as to require only a small mention here. Electronic flash is virtually mandatory in the compact, point-and-shoot cameras. Indeed, many of these point-and-shoot machines couldn't take the excellent pictures they do were the flash not built-in or directly coupled to the exposure system. The idea is that when the user aims the camera in directions of heavy side or backlighting, the camera recognizes that it is looking at an impossible brightness range and fires the flash to balance the deficit in the shadows. In most cases the system works excellently.

But medium format equipment hasn't progressed this far. The flash unit is usually an optional accessory, and its use is decided by the photographer alone. The size and power of the electronic flash is entirely a personal option. Perfectly adequate flash units that are moderately powerful are available and will mount to the camera accessory or hot shoe. These self-powered units are often all that you need for most flash chores. On the other hand, higher power units—generally comprised of a flash head and a separate battery/power pack and mount to the camera via a substantial bracket—expand the range and the options of the photographer.

The general rule of thumb with a flash unit is to "use enough gun;" that is, to get a unit with more power than you think you need because you'll probably need it anyway. Guide-numbers (the measure of a flash's power) are a bit like engine horsepower; muscle doesn't always imply agility. I have several flash units used specifically for medium-format applications. They range from the Osram VS300 Studio through to the powerful Osram S440 Studio. The S440 is a handle-type flash with a

The Hasselblad Pro-flash 4504 is made for the 500-series Hasselblad cameras. (Courtesy: Hasselblad.)

separate high-voltage power pack. For even more flexibility and power there is the Multiblitz Profilite system, a compact, modular multi-head studio-type strobe set with built-in halogen modeling lamps. Although it is a powerful system, the major components—flash heads and control modules—still fit in an average-size camera bag that can be placed under the seat of an airplane.

Working With Electronic Flash. Working with electronic flash is really quite simple. In fact, because most modern on-camera or bracket-attachable flash units have become so intelligent, it is difficult to get into too much trouble. For now, it is hardly necessary to go into the technical details of how an electronic flash works; this subject is covered tirelessly in various books and magazines. Basically, the light emitted from a flash tube is designed to mimic the color temperature of mean noon sunlight. In other words, if you use flash in conjunction with sunlight there will be no noticeable shift in the color between ambient and flash illumination. Electronic flash tubes discharge at amazing speed; the flash duration may be as "long" as about 1000 seconds and as short as 1/65,000th sec. Where the unit is self-sensing, the exposure is monitored and cut off when the unit and the computer circuit in the camera determine that the illumination was sufficient. A high-speed electronic switch within the flash unit (a thyristor) accomplishes this feat, and accounts for

This Bronica GS-1 has a Speed Light G-1 electronic flash attached. (Courtesy: Bronica.)

the flash unit's variation in the light pulses' duration. The farther away, or the darker the subject, the more illumination is required and the longer the flash pulse will be.

If the camera has built-in TTL flash monitoring, then it is simply a matter of connecting the flash to the camera via the hot shoe, setting the ISO on the flash unit to match the film, and selecting an *f*-stop that matches the proposed shooting range. Some cameras, Hasselblad and the Bronica Si series for example, have the sensor in the camera, and the control circuit in the accessory module and flash. But the Rolleiflex 6000 se-

ries with their built-in ambient-light metering systems as well as their dedicated flash metering, permit the use of both systems simultaneously. This results in fully automated synchro-sunlight capability. The Rollei FM-1 flash meter will couple directly to the TTL OTF sensing system and allow metering of any electronic flash off the film plane by spot or average metering. Additionally, it will monitor flash exposure while shooting and indicate under- or over-exposure in one-third stop increments. To my knowledge there is no other camera system that permits metering OTF from any flash during the actual exposure.

Studio Flash. Working with a studio flash does make life a bit easier. None of the portable, on-camera flash units have modeling lamps built into them. It is the modeling lamp that makes for an easy life. Consider this: The actual lighting is only a split-second burst from the flash tube. The confirmation light on your flash unit may indicate that the exposure was good, and the flash meter (if you used one) probably measured it right, but you still didn't actually see what happened. But with a studio system, each flash head usually has its own built-in tungsten or halogen modeling lamp. The modeling lamp either surrounds or is surrounded by the flash tube, and its light generally covers the same area as the flash tubes. Arrange the shot, set up the flash units, turn on the modeling lamps, and take a look at the result. Don't like the way the shadow falls on the subject's face? Move one or more of the strobes. Want a "kicker" on the hair but not spilling onto the face? Put a snoot or a barndoor on the flash head and control the exact angle and strike of the light to taste. Need a colored-effect light someplace on the subject? Mount a filter holder to the flash, slip in the filter or gel you require, and presto, it is done.

Once you have the lighting arranged to your satisfaction, simply connect your flash meter to the flash/camera synchronization cable, bring the flash meter to the subject, aim the receptor back towards the camera, and press the button. The flash(es) will fire, and the meter will read the exposure.

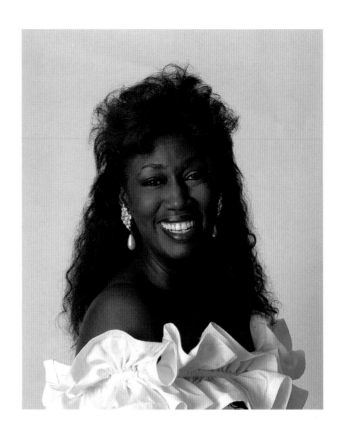

Here are three setups for using one, two, and three light sources for shooting portraits in the studio. The first setup above is just a large diffusion box for soft, directional lighting on the subject. The second setup adds a hair light, a small "kicker" light behind the subject to highlight the hair. The third has the addition of a light umbrella to fill in any shadows on the subject's face. (Photographs by Butch Hodgson.)

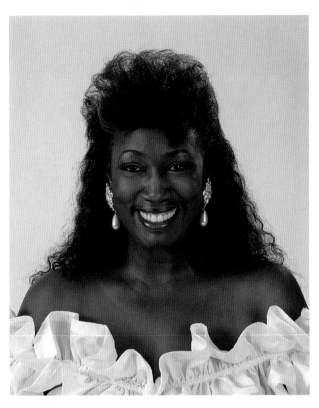

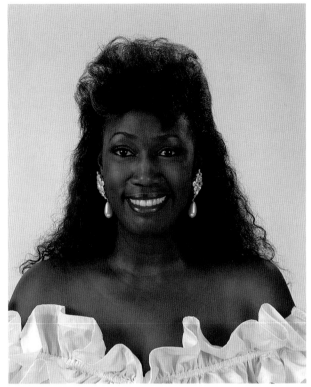

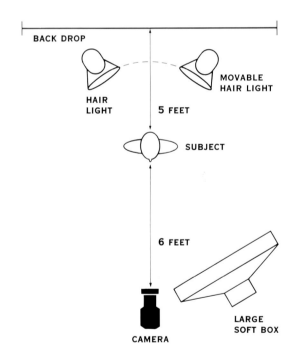

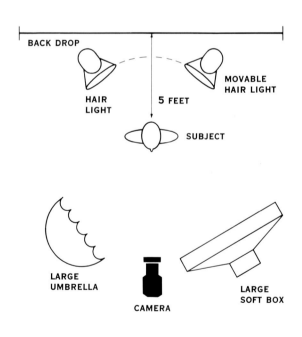

These moody still lifes could only be achieved by using electronic flash units in the studio. (Photographs by Lucille Khornak.)

Note that when you are using multi-head setups the flash units may be hard wired together to fire in unison, or they may be fired by the main flash using either the built-in light sensor slave trips or by plugging in optional slave sensors. Slave flashes are simply units that are "ganged" to the master flash by a cable, light, or infrared sensor. If your system doesn't have slave sensors (and almost all studio units do in one form or another), you can buy slave triggers from any number of sources. The advantage of using nonwired slaves is that it leaves you free to put flash heads wherever you might require them. In theory, it would be quite possible to light a huge area by simply mounting flash heads at intervals and having them fire from a single master flash. The master flash doesn't even need to be part of the studio flash system. It could be a fairly small, on-camera unit, giving you absolute mobility with the camera. But note that slave triggers aren't picky about who fires them. Any flash going off in the vicinity will set off your bank of strobes. One solution is to use coded-pulse infrared trippers and receivers. The receivers only recognize the master flash's code and therefore don't respond to any other photographer's flash unit.

WORKING WITH FILTERS

No matter what anyone says, you don't need lots of filters to make good photographs. As far as I'm concerned, filters are just adjuncts to the image process. Optical special-effect accessories have "bloomed" in the past few years as photographers have sought more ways to enhance their images. There are a number of special-effect filters available from the simple soft-effect diffusers (the classic is the Zeiss Softar) for dreamy images, to multi-faceted devices that produce pictures that look as if they'd been shot through a fly's eye or a crystal chandelier at the local opera house. Some are genuinely creative, in that they do permit the photographer to shift the mood of an image. Others should probably never have been invented. But, as the saying goes, if it were not for the difference, it wouldn't be a horse race.

I'm still not sure if special effects actually enhance one's creativity or detract from it. I use special filters sparingly, because if overused the effect can easily become an unspecial stereotype. A number of professional photographers have made a name for themselves with these special filters, and more power to them. For myself though, I'd rather shoot the image "straight" and, if I choose, add the effects afterwards. However, I do shoot manipulated images occasionally if I feel that either the scene or subject warrants it, or that a manipulated image would help the picture "tell the story" better. If the reader wants a

A very lyrical landscape demonstrates the effective and understated use of a diffusion filter; actually, it is just a very light smear of oil on the outer edges of a UV filter. (Photograph by John Chakeres.)

guideline for filters and special-effect devices, it must be to use them sparingly; however, a few filters are virtually mandated for most of medium-format work.

Center, or Equalizer, Filters.
Although touched on briefly, wide-angle lenses do have rather

special filter requirements. It is an optical fact of life that all wide-angle lenses suffer from some degree of optical vignetting. The wider the lens, the greater the angle of view, and the greater the optical vignetting. This, of course, produces an image that is less exposed towards the edge of the

frame and is particularly noticeable in panoramic cameras with lenses such as the Super Angulon 75mm. Center filters, or neutral-density (ND) filters, are designed to counteract the unavoidable fall-off (vignetting) of the light transmission through the edges of very wide-angle lenses. A center filter is, as

its name implies, a neutral-density filter that is darker in the center and fades to clear at its outer edges. This balances, or equalizes, the light transmission across the lens' entire field of view. They are available in thread sizes to fit most lenses and have exposure compensation values (figures that represent the exposure increase needed to bring the image to the proper exposure when a filter is used) from about 2X to 8X.

You usually need a center filter when photographing large, evenly lit areas, such as skies, large expanses of water, and continuous tones. If not used, the edges of the picture will appear darker than the center of the image. Of course, if you shoot only negative material, you can correct the transmission shift in the printing by simple dodging. With reversal film though, this can't be easily done. If you shoot negative material and have it duplicated onto transparency film, or what is known in the trade as a ''reprodupe,'' you are back where you started. However, it is quite tricky to hold back parts of a negative when printing a 1:1 copy. If you have a 6 × 17 negative and want a 6 × 17 slide, good luck. Think carefully about your final applications and requirements, and understand that you'll need a center filter somewhere along the line. And remember, light transmission roll-off of these wide-angle lenses is the same for flash as it is for ambient light, so saying that you do mainly interiors won't save you, either.

So what lenses show transmission roll-off? Well, the Fujinon 105mm lens on the 6 × 17 Fuji Panorama has a little bit; the 90mm lens on the Linhof Technorama 6 × 17; the 65mm on the Linhof Technorama PC 6 × 12; and, the Plaubel Proshift's 47mm Super-Angulon quite a bit. The Biogon 38mm for the Hasselblad 903SWC, by virtue of its design, shows virtually no roll-off. The key lies in the nature of the optic, irrespective of the camera. Of course, there are other ultra wide-angle lenses by other camera and lens manufacturers, and you should check the data for your own lenses.

Independent versus OEM. It was the price of original equipment manufacturers' (OEM) filters and the argument that an independent filter wouldn't work well that brought on a test of independent versus OEM, or to be more precise, Heliopan versus OEM. Consider for a minute—and these are rough figures—that a 77mm OEM center filter for a wide-angle lens will cost around $600. Tack that on top of a few thousand dollars for the camera, and you start getting a bit gun shy. An independent manufacturer's filter, on the other hand, may cost around $300. The tests were performed on assignment, using slow-speed reversal film, specifically ISO 50 and 100 stock. Assuming the old sunny-sixteen rule as a general descriptor, ISO 50 would be equivalent to 1/60 sec. at f/16, or 1/125 sec. at

These surreal coastline photographs show how using an ND center filter can help alleviate the problem of vignetting with the wide-angle/wide-field cameras. The top image was made without a filter, and vignetting appears along the edges of the top photograph. These dark areas were eliminated in the bottom image by using a center filter. (Photographs by Joe Meehan.)

f/16 for ISO 100. The recommendations are to stop down two stops from maximum aperture to engage the filter, and then increase the exposure by the value of the filter. For example, with a 2X ND (center filter), f/16 at 1/125 sec. should now be f/8 at 1/125 sec. to correct the exposure. Stopping down to f/16 at 1/30 sec. would increase the depth of field, but then you would have to worry about camera movement. No one said that working with filters was easy.

Armed with two sets of filters, two OEMs and two Heliopans, I set to work. The OEMs were designed for the Super Angulon lenses and performed exactly as they should. The Heliopans were used both on the Super-Angulons and the Fujinon, and they worked equally well. To tell the truth, I believe there is not a scrap of discernible difference between the OEM's and the Heliopan's performances. Both sets of slides are equally balanced, the color shift is natural, there is no haloing effect, and the focus remains unaffected. The exposure was varied between one-and-a-half and two stops compensation so that I had a choice of a slightly lighter or a slightly denser slide. The exposure differential curve was steeper with the ISO 50 film but that is a property of the unforgiving nature of that particular film and not a product of the filter factors used.

Truthfully, the 105mm Fujinon, which covers 6 × 17, hardly ever requires a center filter because its transmission roll-off is marginal. However, the effect of the Heliopan 0.45 ND center filter is still

noticeable. To be exact, the 0.45 Heliopan is rated as having a filter factor of 3X. Finding this difficult to believe, I used a spot meter to look through the filter and figure out the values accordingly. A factor of 2X will probably suit most. In all cases the images are technically correct, and the idea of paying a few hundred dollars less for a center filter is excellent. Listen, if you are in accessory sticker shock, it does no harm to shop around. In all cases, though, test before you commit.

Polarizing Filters. A polarizing filter is perhaps the single most useful and effective device that can be mounted in the light path. Light reaching the eye or the camera lens unfiltered is said to be unpolarized, that is, the light waves are vibrating in all directions perpendicular to the light path. When this light strikes a reflecting surface (it can be anything from glass, water, shiny wood surfaces, metal, or glossy painted areas) at an angle of between 30 to 40 degrees, it will become polarized from the observer's point of view. This natural polarization will cause the light waves involved to vibrate in one direction only. Of course, all of this bouncing around produces reflections that have a concealing effect as well as a revealing one. Light scatters, ricocheting around, and—from a photographer's point of view—de-saturates colors, often diminishing their pristine intensity. Just looking through a polarizing filter while rotating it often reveals a world of vibrant intensity that usually goes unnoticed.

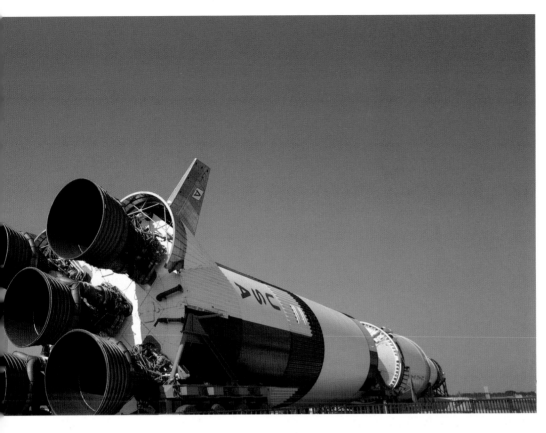

A Linhof Technorama 612 PC camera with a Heliopan center filter was used to take these images of the famous Saturn V booster assembly outside the VAB at the Kennedy Space Center, Florida. I made the top picture without the filter and the bottom one with the Heliopan Wide-Angle Equalizer ND 0.45. The exposure compensation with the filter was 2 stops. The effect that center filters have can be subtle but telling.

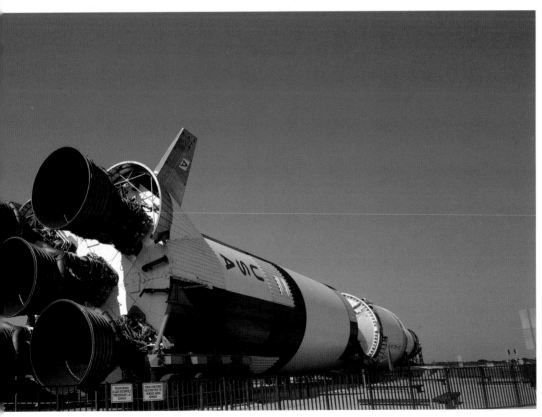

The top image of the Burnsides Bridge in Sharpsburg, Maryland, was made using a polarizing filter. Note the decrease of reflection in the water and the deeper shade of blue as compared with the bottom image, made without the filter. (Photographs by Butch Hodgson.)

Most of us wear some form of polarizer every sunny day, especially where there is intense glare. Sunglasses, many of which are polarizers, help reduce the glare that is often prevelant. In fact, one of the errors committed by a lot of photographers is taking pictures while wearing polarizing, or for that matter, any kind of sunglasses. It is important to see the scene as it really is in order to be able to decide whether to apply optical remedies. So, a polarizing filter ''cleans up'' the light on the scene causing colors to become more vibrant and intense by eliminating a lot of the spurious reflections that denature it.

Maximum polarization occurs at an angle roughly 90 degrees to the direction of a line drawn from the sun to the camera. Point the filter away from this line and the polarization effect will progressively diminish as the angle increases. This helps explain why polarizing filters with wide-angle lenses only partially polarize the scene. If you shoot a skyscape with a wide-angle lens, only part of the sky will have that intense polarized blue, and the wider the angle of view of the lens, the smaller the polarized segment.

Naturally the polarizing filter may be used with exactly the same effect using either an SLR or a nonreflex camera. The only problem is that when using a rangefinder camera, you can't see the effect through the lens. To remedy this, simply hold the filter up in front of your eye, viewing the scene as the lens would, and rotate the filter to obtain maximum polar-

ization. Then mount the filter on the lens in that same position. In order to make life easy for nonreflex users, some polarizers have calibration marks or numbers set around the rim so that as you turn the filter a number comes up against the index. The filter is mounted with the index centered upright along the lens axis and the number is realigned with the index when mounting the filter.

If the camera has TTL metering then the exposure factor is automatically taken care of by the metering system. But if you are setting the exposure by eye or using a handheld meter, the exposure factor must always be remembered. You can hold the filter in front of the cell or optical system of your meter and simply read through it when you determine the polarization. But you can't use this technique with an incident light meter.

When should you use a polarizer? Basically, whenever you feel it will enhance a scene, or whenever it is important to maintain the vibrancy and impact of the color in the scene. Use it whenever you wish to eliminate an annoying reflection resulting from the glass over a picture or even the gloss on an oil painting. If the reflection is still annoying, it could be that you are trying to polarize a direct reflection; in this case, angle the camera in relation to the subject. The polarizing filter is also useful for helping to cut out a lot of atmospheric scatter, or the refraction of light rays when shooting, say, aircraft in the sky. Also, the polarizing filter doesn't have to be used over the camera lens; light sources may be polarized, too. If you polarize a light source, be it incandescent or flash, and put a polarizer over the camera lens, you can almost guarantee that there will be no reflections.

Ultraviolet, or Haze, Filters. These are generally plain (uncolored) filters that cut out any ultraviolet (UV) light. The ultraviolet part of the spectrum is responsible for the hazy effects seen across landscapes, softening the scene and generally wreaking havoc with pictures shot near large expanses of water and woodlands. Ultraviolet is an energetic wavelength and passes readily through many optical glasses. It also has a rather unfortunate effect on film emulsions by increasing the level of blue recorded.

Most photographers keep a UV filter permanently in place on the lens as a sort of clear optical lens cap, figuring that it is less expensive to clean or replace a UV filter then a front lens element. This is good common sense, but remember, all filters have some power, however slight. Because of this, you should only buy top quality filters. In addition, there are two approaches to making filters. The first way sandwiches the filter material between two pieces of optical glass, while the other approach dyes the filter glass in a mix. The advantage to using filters manufactured from dyed glass is the better distribution of the dye in the filter, and therefore more accurate diffusion. It is also important to note that most modern lenses are comprised of UV absorbing glass, so the UV filter is simply additional insurance; besides, in terms of color photography, a polarizer deals with haze more effectively.

Colored Filters for Black and White. With black-and-white photography there are a number of approaches to improving haze penetration, and adding a colored filter is often the most effective. Yellow is the gentlest, but orange or even red will improve light penetration. The filter simply diminishes the film's response to certain areas in the spectrum. If you progressively eliminate the film's ability to "see" blue, then it will shift its response farther into the longer wavelengths of light that have a better haze penetration. The penalty for such extreme measures is that the film's balance is disturbed and the contrast may climb unacceptably. Such remedies should be applied judiciously, with careful thought for the consequences.

Graduated Density Filters. Probably rising out of the needs of landscape photographers, these filters are also graduated neutral-density filters. For these, however, the maximum density is at the top of the filter, where it would most likely cover the sky, and tapers off towards a horizon line about two thirds down the filter. The idea is to bring a bright sky and a darker landscape within the brightness range of the film and has nothing to do with vignetting. These filters may also be obtained in a warm-up type that is designed to add a warmish tone to color images by virtue of its soft amber tint.

SPECIAL CONSIDERATIONS

CLOSEUP, MACRO, AND SCIENTIFIC PHOTOGRAPHY

Closeup lenses and teleconverters are important items in a photographer's equipment cabinet. Frequently referred to as diopters, closeup lenses go in front of the prime lens, while tele-converters go between the lens and the camera body. Both increase the image that the prime lens produces, but for different reasons.

First, though, let me cover the image ratios that are involved on closeup photography. If 1:1 is life-size, then the subject will be reproduced on the film the same size as it is in life. Increase the magnification to 3X, or three times life-size, and the image will overfill the frame; that is, only part of it will be seen on the focusing screen. Now consider this: if the magnification is left at 3:1, and the only change then made is to the format—that is, the same, say, 150mm lens is used and the same distance is maintained between the subject and the film plane—assuming that the lens is capable of covering a larger format, the image ratio could be reversed.

For example, when you use an 80mm lens designed for a 6 × 6 format with a film area masked off area for 24 × 36mm (35mm), the lens becomes a moderate tele-photo, not because it has changed, but because less of the image it projects is being used. It is actually easier and cheaper to invest in different format film backs than to invest in all the closeup equipment. There are quite a few medium-format cameras with interchange-

able film backs of different formats available.

Closeup, or Diopter, Lenses. It is interesting to observe how a closeup lens works, and why. If you try to focus a lens closer than its optics allow, it obviously won't work. But that is precisely what happens when you try to shoot closeup with lenses not designed for closeup work. Think of a far-sighted person trying to read a menu by holding it at arms length. If their arms aren't long enough, they put on reading glasses. This allows them to read the small print at a more comfortable distance. Reading glasses are simply lenses of a specific power, functioning much like diopter lenses do for ordinary, or prime, lenses.

It follows then that if the prime lens is brought closer to a subject by adding a diopter lens, then the subject will appear larger in the viewfinder and on film. Diopters come in various powers, but it is seldom a good idea to go to powers or combinations that are greater than about 3X. They also offer no decrease in the speed or quality of the prime lens, are light and compact to carry, and they work just fine with flash. Naturally you can use diopters with zooms, too.

The Hasselblad can be adapted for very closeup work by using it with bellows and the Luminar macro lenses. In the top photograph, the assembly is operating in a translucent copy mode; that is, electronic flash located beneath the glass stage is passing through the subject, somewhat like light passing through a stained-glass window. In this case the subject is an autumn leaf showing two stages of magnification: 2X on the left and 5X on the right. (Photographs by Ernst Wildi, Hasselblad.)

The image size produced when using a diopter can vary slightly according to the focus of the lens in use; the smallest magnification occurs when the lens is focused at infinity, the greatest when it is at its closest focus. There are also split-diopters that work much the same way as a set of bifocal glasses. The bottom part of a split-diopter is of a specific magnification or power, and the top part is either nonexistent or just plain glass. The idea is that part of the image is then closeup and sharp, while the other part is still focused at infinity. (I don't really care for them all that much, but they do work well.) The important thing to decide when working with split-diopters is where to place the horizon line between the closeup and distant subjects. Obviously there is a jump in sharpness between the two areas. This has to be carefully buried in ''busy'' parts of the picture in order to render the split more or less invisible.

In practice, closeup lenses are more successfully used with normal-to-medium telephoto lenses. Using a lens longer than 80mm permits large, frame-filling images without the lens, camera, or photographer crowding the subject. This in turn means that the lighting is easier to handle because you won't be shadowing the subject. Using diopters on telephoto lenses is also useful for keeping bad-tempered subjects—rattlesnakes, scorpions, or the like—out of range of the photographer.

Diopters, or closeup lenses, have another elegant virtue: they don't alter the speed or light transmission of the lens. Bellows and extension tubes do have an effect because the farther away from the film plane you shift the lens, the greater the decrease in light transmission. Remember, lenses are designed to work within certain definite parameters.

The Hasselblad with extension bellows and a Zeiss Luminar macro lens is poised for work in the field. Note the extension rails that enable the camera assembly to be moved bodily for focusing. (Photograph by Ernst Wildi, Hasselblad.)

Teleconverters are a great solution to the problem of carrying extra lenses into the field. (Courtesy: GMI Photographic.)

Some photographers argue that using a closeup lens erodes some of the sharpness and contrast of the prime lens. This is largely untrue, unless you buy cheap diopters. Most manufacturers offer closeup lenses that are optically equivalent to their own lenses. There are even a few lenses that come specifically packaged with a closeup diopter to produce frame-filling closeups without additional mechanical boosters.

Teleconverters. Teleconverters perform a slightly different function than diopters and have been the recipients of some undeservedly bad press. A top flight teleconverter from a reputable manufacturer is as much a precision instrument as the lens it is designed to complement. Basically, a teleconverter is a series of negative optical components that are highly corrected. The unit mounts between the lens and the camera and moves the lens farther away from the film plane. It is the negative element of the converter that

moves the image back to the film plane, thus increasing the power of the original lens. There are both independent-made and OEM teleconverters available. My advice in this area is to buy the OEM converters matched to specific lenses.

One of the main problems with teleconverters is a loss of lens speed. Most teleconverters are about 1.5X or 2X in magnification (converters with powers higher than 3X aren't recommended because they degrade image quality too much). If a 2X converter is used, you lose about two stops. For example, if you use a F5.6 300mm lens with a 2X converter, it will become a F11 600mm lens, not too much of a sacrifice for doubling the original focal length. Of course, inserting a teleconverter between the lens and the camera does increase the physical length of the assembly and adds one another weight-bearing surface. Absolute rigidity is essential, and modern high-tech teleconverters live up to the reputation of the manufacturer. I use an OEM con-

verter compatible with Zeiss telephoto lenses designed for the Rolleiflex 6006 Mk2 and find it indispensable. Not only does it give me two lenses for one, it does so without the additional weight and bulk of the equivalent focal-length prime lens.

Bellows and Extension Tubes. Just as with 35mm photography, medium-format cameras have at their disposal an excellent array of lenses specifically designed to focus in very close on the world. Closeup photography may be divided into two parts: either using a rigid lens barrel, more commonly referred to as an extension tube, or using a bellows system. Bellows have the advantage of offering greater extension and thus greater image magnification, plus the ability to use almost any lens to produce large closeup images, sometimes around 3:1. An extension tube is obviously more limited in its travel, and the maximum image magnification it offers is around 1:1, but it is more rugged than a

bellows and generally easier to deal with in the field.

Bellows and extension tubes should also be of the full coupling type to allow the lens to communicate with the camera body. In fact, many of the new electronically controlled cameras are virtually lobotomized when deprived of communication with their lenses. Extension tubes will also frequently come in sets. Individual tubes may be combined to get as close as possible to the lens extension you need. Some of the lenses designed for bellows or extension tubes also incorporate some degree of focusing within the lens barrel. This is to permit fine tuning of the extension and focus. A bellows, on the other hand, is a continually adjustable extension system and may even be capable of some shift movements.

Closeup photography with a medium-format camera is no more difficult than with any other type of camera. Most medium-format cameras offer some form of TTL metering, if not built-in, then by the judicious addition of a metering prism. If most of your closeup photography requires electronic flash as the primary illumination source, you should choose a camera that meters flash TTL; otherwise a good flash meter is a must. Come to think about it, you might find that a dual-mode meter—both ambient and flash—is a good investment.

Macro Lenses. The operation of a macro lens obviously depends upon the designer and manufacturer. A macro lens won't focus

unaided to a 1:1 image ratio, but quite a number of lenses produce excellent closeup images at about 1:4. If the camera has built-in bellows, then the image may be increased to 1:1 or even better. The Rolleiflex SL66 series cameras with their built-in, long extension bellows can focus to within inches of the subject, especially if you also use a reversing ring. Rollei's new lens for the Rolleiflex 6006 and 6008, the Macro Apo Symmar F4.6 150mm, can focus to 1:1 using the accessory bellows. The Macro Planar F4 120mm has its own focusing mount and can go to 1:4 unaided. With extension tubes, reversing rings, and bellows, macro lenses for medium format perform as well as those meant for 35mm.

Are the nonmacro lenses used as closeup systems as good as true macros? Simply, no. A macro is a highly corrected optic designed for a specific purpose. The fact that it might also focus at true infinity is just an asset. Some people use macros as general purpose lenses, and this is both good and bad. If you need a 120mm lens and you can't afford both a normal lens and a macro, by all means buy the 120mm macro if it will focus at infinity. Using a nonmacro lens for closeup work is a personal choice. Obviously, a wide-angle lens used for closeup will produce an exaggerated amount of distortion, but if you don't mind the perspective, then by all means use it.

There is little point in using a lens where the subject is literally jammed against the front element. I know this is frequently touted as

a virtue with macro zooms in video cameras, but the reason is somewhat different. Moderate- and even super-telephoto lenses may readily be used as long-distance macros. They make it a lot easier to use more conventional flash units, too. Ring-flash units are special units designed for closeup and macro work and have a flash head that fits around the front of the lens for direct illumination. Because of their configuration, they seldom have very high power. A standard flash unit can generally belt out enough flash to satisfactorily illuminate a small subject at several feet.

Using long lenses on well-extended bellows is not always a good idea, and the feasibility of this technique varies from camera to camera. As more weight is applied to an extended bellows, the liability of bending the optical axis increases. Some manufacturers offer an accessory support bar that comes with some of their telephoto lenses. The lens focuses using the built-in bellows, and as it is focused, the lens runs along a support to help keep the optical axis parallel. Usually a short extension tube won't cause problems because it is mechanically stiffer. Unless you require infinite variations, this is frequently the best way to go. Another point is that using the focusing ring of a lens with either a bellows or extension tubes will also slightly effect the image size. The accepted technique with handheld telephoto closeup photography is to physically shift the entire system towards or away from the subject.

If you elect to use a tripod, then you may need a focusing rack assembly; the camera and lens is mounted on this, and the whole system then mounts on the tripod. Moving the assembly by rack-and-pinion physically shifts the camera towards or away from the subject and avoids tiresome readjustments to the tripod. When working without a tripod, the technique is to find the image size and focus you require, and then gently move the whole assembly backwards and forwards for best focus. It takes a bit of practice, especially when you get into high-image magnifications. You'll have to keep a sharp eye on the image on the focusing screen because it will zip in and out of focus rapidly. Not unlike

target shooting, handheld macro photography requires that you eliminate any variable that would produce images that are unsharp due to camera shake. The first steps are to ensure adequate depth of field when possible (this will take care of any last-second twitchings as you release the shutter) and the highest possible shutter speeds to combat camera shake. Breathing is one of the worst culprits causing camera shake. Remember, when you are at "high-magnification," the camera is sensitive to the fact that you are inhaling and exhaling. Wherever possible, reduce unwanted shake by controlling your breathing and also by resting the camera against a solid object.

Reversing Rings. Photographers frequently resort to reversing a lens in macro work. The reason is that at image magnifications higher than 1:1 the lens produces a better image if reversed. Reversing rings are handy gadgets to have around. They do, however, come as two species: coupling and noncoupling. If you look at the back of your lens, you'll see either a set of electrical contacts, a set of mechanical ones, or both. These contacts or coupling levers are designed to make the lens diaphragm and the shutter operate in concert with the camera. If you use a noncoupled reversing ring, or for that matter a noncoupled extension tube or bellows, the control functions of the camera are disabled.

The reversed lens on this Rollei SL66X is one way to adapt it for macro photography. (Courtesy: Rollei.)

This camera setup for a closeup shot of a butterfly includes a reversed lens and full bellows extension with flash units on a Rollei SL66X. (Courtesy: Rollei.)

So, always try to buy fully coupling reversing rings and accessories. This is particularly important if your camera equipment uses such shutters as those found in the Rolleiflex 6006 and 6008 series cameras. These electrically driven, linear-motor type shutters obviously require power. Where the shutter is a between-lens, spring-driven system—such as Compur, Pronto, Seiko, or Copal—a coupling reversing ring is not quite as critical.

Closeup Work with Rangefinder Cameras and TLRs. Although some might disagree, closeup photography with rangefinder cameras is not the most practical of endeavors. Some systems, though, have an optical adaptor that covers the viewfinder and the lens, thereby increasing image magnification and reducing parallax. A set of "legs" extend from the adaptor towards the subject and define the distance and the area coverage. But on the whole, trying to make a nonreflex camera perform closeup tricks is an essay in ingenuity, ungainliness, and inelegance.

TLR cameras, on the other hand, can function closeup quite well. The major obstacle is the parallax between the taking and the viewing lenses. Naturally, as you move closer and closer to the subject, the parallax of the two optical axes becomes more noticeable. Imagine two parallel lines that are horizontal and spaced two inches apart. These represent the optical axes of the taking and the viewing lens. Each lens actually "sees" different parts of the image when close to the subject. Normally, on the TLR the viewfinder mask or sliding viewfinder bezel, connected to the focusing system, moves to compensate for parallax. But if you move closer to the subject than the built-in compensation system can cover, then parallax error can't be self-corrected by the camera.

There are a couple of ways to ensure parallax correction. One is to employ a set of closeup lenses in matched pairs. The taking closeup lens is a fairly conventional diopter of a specific value, say, 2X. The viewing lens is a diopter of the same value but has an optical deflection wedge built into it. The wedge corrects the

viewing angle to converge with the angle of the taking lens. But even the most elegant optical wedge can't operate at very close distances. Eventually there comes a point, especially if a long bellows extension for focusing is available, when the viewing lens is staring right at the subject and the taking lens is not at all.

There is a basic solution for this: simply jack the camera upward the same distance as that existing between the two lens axes. Focus first, and then move the taking lens into position. For example, imagine there is a two-inch separation between the two lens' axes. With the camera on a center-column tripod, mark the distance of the required lift on the tripod. Focus the subject, and then crank the tripod up to bring the taking lens into position. This isn't difficult, but it is time consuming. Hopefully, the subject will remain in its original position while you perform this task.

High Magnification. SLRs are also the least awkward cameras for producing high-magnification images without a microscope. There are special lenses made for some medium-format SLR camera systems that produce images from about 3X to 25X using bellows. The Zeiss Luminars designed for Hasselblad are examples of very high-order, special objective lenses. Like their larger cousins in the large-format world, they are mounted on simple lens boards that snap into place on the front standard of the bellows. Aperature

diaphragm operation is manual: that is, you open up the lens aperture for focusing, and then turn the ring to the desired working aperture. Remember that when the system is operating manually without signaling between the lens and the camera, TTL metering is performed at the working aperture. This, of course, applies to flash and to ambient lighting. If you're using a separate meter, then the extensions must be compensated for in the exposure.

For high-magnification work, it is also useful if the camera features mirror lock-up. The idea is to release the mirror shortly before releasing the shutter. This lets all the camera's mechanical vibrations fade away before the picture is taken and avoids mechanically induced camera shake. The effect of the mirror's movement may seem negligible in normal photography, but when you go to macro, super-macro, and micro photography, the magnification applied to the subject also increases the observable effect of vibration. No matter how shake-free the camera is internally, a reflex mirror has quite a lot of momentum.

When photographing very small, mobile subjects closeup, pre-releasing the mirror may not be the best way to go. A tiny beetle that appears to be crawling across a leaf is actually moving rather swiftly under high magnification. Sometimes it is better to compromise by increasing the light source (bring the flash head closer) or use a faster film to permit faster shutter speeds. This is not so much

for their action-stopping capability, but to avoid any vibration at higher speeds.

Astronomical Photography with Medium Format. Just as the medium-format camera is excellent with terrestrial photography, it is also an excellent astronomical instrument. It all depends on what the reader considers to be astronomy, for it is not always the domain of super telephoto lenses and the like. Of course, the narrower the angle of the sky you wish to photograph, the longer the focal length you'll need. But lots of good images come from much shorter focal-length optics, even super wide-angle lenses. Some astronomical photography simply involves mounting the camera and telephoto lens on a tripod and making very short exposures of the moon. Other types consist of simply setting the camera on a tripod, aiming it at the night sky, and locking the shutter open for a few minutes or even hours. This produces star and planet trails across the film, and if you are lucky enough, the trail of a meteorite burning in through the atmosphere. Many beautiful images are made this way.

Other techniques are classical astronomical ones: mounting the camera on a tracking mount or piggyback on an astronomical telescope. Remember that thousands of superb images were brought back from earth orbit, lunar orbit, and the lunar landings, all shot with medium-format cameras. Indeed, the medium-format camera

These images of a solar eclipse were shot in Nebraska using a 7-inch Questar Cassegrain telescope with a 2000 FCM Hasselblad. A full axis solar filter with metallic chromium coating was used to tame the light and heat. The reader should be advised that these filters may be expensive, but they are vital. Never look through any lens, especially a telephoto lens, at the unfiltered sun. Proper solar filters mount ahead of the optical system and reflect the light and heat away from the system. Filters placed inside the optical system can be dangerous because they can shatter under thermal loads. (Photographs by John G. Clothier, MD.)

features heavily in the current space program. Hasselblad cameras have gone to the moon and are still favored for handheld use on board the NASA space shuttle. Other cameras—such as the Linhof Aerotronica (actually a medium-format, 70mm rollfilm camera), the Rolleiflex 6008, and the Bronica—are finding applications in space. There was even a short manual produced by Hasselblad on how to take pictures in space. Not only does it have information on how to use the camera technically, the manual also covers the esthetics of composition!

TRAVELING WITH EQUIPMENT

A lot of photography requires travel. Even if you are the most sedentary of photographers, equip-

ment does have to be shipped occasionally. Whenever it has to go in the hold of an airplane, it should go in the best case that is available. Several thousand dollars worth of cameras, lenses, and accessories deserve a good case. I use several types, and the old standby, the Halliburton aluminum case, has done sterling service for me on many trips. But they do tend to dent and get somewhat battered; and they also scream "cameras!"

Andiamo offers a military specification ABS plastic case that is immensely strong and has, so far, withstood everything that the baggage mishandling systems at airports can throw at it. There are special latches all around the case that cinch the edge-seals and render the case completely weather-

proof; so much so, in fact, that a pressure bleed screw is incorporated into the case so that air may be bled in or out in order to make opening the case easier after a trip in unpressurized cargo holds. Rimowa offers a nice line in camera cases; one particular favorite with the "press boys" is the Rimowa UltrAlight series. They are shoulder type, "gadget bags" that are immensely strong. You can pack a phenomenal amount of gear into a fairly compact bag. It also makes a good seat for the weary and a strong base to stand on for better elevation in a crowd.

Soft bags have their place, too. I generally carry a soft case with a camera and a couple of lenses onto the plane with me just in case. The larger, soft-sided gadget bags are also good for field work where a lot of things other than cameras and lenses have to be carried. With soft bags, bigger is better. There is nothing worse than getting out to a location and finding the one thing you needed is back at the motel room. Black camera cases may be stylish, but they are an anathema in hot, sunny weather. The temperature inside a black camera case left in the sun can get to ruinous levels for film since film is very sensitive to heat fogging. It is a good idea to pack your equipment in a cool environment as you prepare for a day's shooting. If you wrap the film packs in a blanket, or better yet, one of those thin "space blanket" mylar fabrics, everything will keep surprisingly cool. The space blanket can then be draped over the camera case while you are working.

All the equipment that you see in the back of my car in the top photograph fit into the Rimowa medium-size Ultralight camera case and soft-pack. In this case, the equipment included a three-head flash unit plus an accessory Multiblitz Profilite outfit. The system makes a compact, lightweight traveling studio, as shown in the bottom picture.

Traveling With Film. Because of the current state of world affairs, air terrorism has become almost a way of life. To counter this, all airports have some form of X-ray baggage inspection system at the gate areas. They also have signs stating that their equipment won't affect most films. They do state, though, that ISO 1000 films are in jeopardy and should be hand inspected. To counter X-ray dosing, and possible damage to film, there are special lead-lined bags available for carrying film. It will then, theoretically, pass through the X-ray device unscathed. The theory is nice, as a theory, and a lot of these bags are sold. But, look at it from a security person's point of view—the lead-lined, X-ray opaque bag could contain film, drugs, or even plastic explosives. Secondly, although lead-lined film bags do work, they only work at peak efficiency when they are fairly new. After a few foldings, the plastic and lead shell can crease and develop minute holes.

In my opinion, putting the film in a clear plastic bag and handing it round for hand inspection is the best and most equitable solution. But, if your film must travel through an X-ray machine, then a lead-lined film bag will protect your film from the worst onslaught of roentgen particles. Are airport X-ray systems safe for slow- to medium-speed films? Yes, and no;

it depends on how new the equipment is, how well it is maintained, and how many passes the film takes through the security X-ray machines. One pass will probably do no harm; several will undoubtedly harm even the slower ISO material.

Working and Traveling with Batteries. The rechargeable nickel cadmium, or nicad, battery has, for a long time, seemed like a godsend to the camera industry. Many of the computer-control systems and motor drives of today demand greater internal power. The nickel cadmium cell is undoubtedly the most ubiquitous of power sources for still and video cameras, but it is both a blessing and a bane.

The main difficulty with nicad batteries lies in their inherent tendency to "memorize" a charge level if repeatedly exposed to it. For instance, if the battery was only 50 percent discharged when the photographer put it on charge, recharging repeatedly at this level causes the battery to accept 50 percent as 100 percent, and so you only get half the nicad's true capacity. But the remedy is simple: Discharge the battery fully before recharging. Most photographers don't do this, and I must admit I am somewhat of a sinner in this respect, although I do occasionally connect a load across the terminals and bring the residual charge to

zero. Connecting a load is really no more than using the battery to power something that will quickly discharge it. I use a halogen 12V projector lamp, and this will drain a fully charged 12V camera nicad in almost no time. A resistor can be used as a dummy load, or, as one photographic colleague of mine does, give the AA type nicads to children (if you have any) to run in their toys for a while!

The charger that is supplied with the original equipment can also be a problem. At best the charging circuit monitors the battery state. At worst, it is a simple step-down transformer that charges the battery at a trickle rate. The Rollei charger starts at a rapid charge and then switches over to a trickle rate as the voltage level in the battery rises to a specified level. Despite this, the nicad pack for the Rollei 6006 and 6008 is one of the best and most reliable that I've used. The packs for the Hasselblad are excellent, too, if treated right. Interestingly, Hasselblad has modified its systems to run on disposable AA alkaline batteries, as well as the rechargeable AA nicads.

One of the banes of all nicad-driven systems is the battery charger; it is just one more thing to travel with. If you have a couple of still cameras that use two different nicad pack and voltage systems, and, like me, if you travel

with a video camcorder, the transportation of the battery chargers is a chore. This increases the growing argument that someone manufacture a single, universal nicad charger. Hasselblad claims that since its switch to disposable AA-type batteries, photographers have been quite lyrical. There may be some truth in this; however, although the AA alkaline is the most obtainable battery in the world, it is not inexpensive.

As someone once remarked: "What am I supposed to do when I am on location in some remote area and the nicads die; plug them into the sky?" Well you can plug them into the sky; at least, into the sun if you have one of those portable solar-cell rechargers designed for just such use. How effective are they? I would say moderately. The power delivered is, of course, dependent upon the light falling upon them, and the charging is very slow. Even the big panels designed to charge RV and boat batteries charge only at a trickle rate. They are good for maintaining charges, and if you have at least three nicad packs you can get by on a solar charger. But it is just one more thing to pack. For traveling in remote areas and for protracted periods of time, be sure to pack plenty of disposable batteries, as well as a system that allows you to charge from, say, an automobile-type battery.

CURRENT MEDIUM-FORMAT SYSTEMS

This book, like all books that deal with technology, is perhaps already lagging behind the changing technology. Nothing can be done about the inexorable advances that permeate all aspects of a photographer's life. So, this equipment chart will inevitably miss some new items. However, the data is valid, the anecdotes in the book are genuine, and, hopefully, the information is basic and useful. Cameras and lenses are one of the few constants in a swiftly changing world. Equipment that is ten years old still takes the same excellent pictures that it did when it was state of the art. I'm not sure if the same could be said of electronic equipment. Flash systems, for example, change with bewildering rapidity, due, in part, to improved ultraminiaturization of the electronics. But there is also a flourishing used camera marketplace, and although manufacturers won't love me for mentioning it, there is no reason why the reader on a restricted budget shouldn't buy used. Indeed, some of the more esoteric items are now only available used. What you buy, and why you buy it is entirely up to you and your needs. If any advice could be given here, it would be not to overload yourself with more equipment than you really need. This way one builds up an outfit comprised of really essential equipment. Small is, even these days, beautiful.

MODEL TYPE	FORMAT	ALTERNATIVE FORMATS	STANDARD LENS	NO. OF LENSES AVAILABLE	FOCUS SYSTEM	SHUTTER	METER	DRIVE WINDER	FLASH SYNCH	WEIGHT
ROTATIONAL SCANNING CAMERAS:										
Alpa Rotoscan SM60/70 panoramic	6 × 6 and 6 × 7	No	75mm f/6.8	2	Reflex	Scanning	No	Electrical	None	16 lbs.
SINGLE-LENS-REFLEX MODELS:										
Bronica SQ-A	6 × 6	Yes	80mm f/2.8	16	SLR	Leaf	Aux. finders	No	X-type	4 lbs. 5 oz.
Bronica SQ-Ai	6 × 6	Yes	80mm f/2.8	16	SLR	Leaf	Aux. finders	Add-on	X-type	3 lbs. 3.8 oz.
Bronica SQ-Am	6 × 6	Yes	80mm f/2.8	16	SLR	Leaf	Aux. finders	Built-In	X-type	4 lbs. 2 oz.
Bronica GS-1	6 × 7	Yes	100mm f/3.5	10	SLR	Leaf	TTL, OTF	No	X-type OTF	4 lbs.
Bronica ETR-S	6 × 4.5	Yes	75mm f/2.8	9	SLR	Leaf	Aux. finders	Add-on	X-type	2 lbs. 12 oz.
Bronica ETRSi	6 × 4.5	Yes	75mm f/2.8	9	SLR	Leaf	Aux. finders	Add-on	X-type TTL, OTF, SCA	2 lbs. 12 oz.
Exacta 66	6 × 6	No	80mm f/2.8	12	SLR	Focal-plane	Aux. finder	No	X-type	4 lbs. 3 oz.
Fujica GX680	6 × 8	Yes	135mm f/2.8	12	SLR R-P, B	Electric-leaf	Aux. finder + TTL monitor	Built-in	X-type TTL, OTF	9 lbs. 2 oz.
Hasselblad 503 CX	6 × 6	Yes	80mm f/2.8	15	SLR	Leaf	Aux. finders	No	X-type TTL, OTF, SCA	3 lbs. 5 oz.
Hasselblad 553 ELX	6 × 6	Yes	80mm f/2.8	15	SLR	Leaf	Aux. finders	Built-in	X-type TTL, OTF, SCA	4 lbs. 11 oz.
Hasselblad 2003FCW	6 × 6	Yes	110mm f/2.8	20	SLR	Focal-plane and/or leaf	Aux. finders	Add-on	X-type	3 lbs. 7 oz.
Hasselblad 500C/M	6 × 6	Yes	80mm f/2.8	16	SLR	Leaf	Aux. finders	No	X-type	3 lbs. 5 oz.

MODEL TYPE	FORMAT	ALTERNATIVE FORMATS	STANDARD LENS	NO. OF LENSES AVAILABLE	FOCUS SYSTEM	SHUTTER	METER	DRIVE WINDER	FLASH SYNCH	WEIGHT
Mamiya RB67	6 × 7	Yes	110mm f/2.8	13	SLR R-P, B	Leaf	Aux. finders	No	X-type	6 lbs. 2 oz.
Mamiya RZ67	6 × 7	Yes	110mm f/2.8	13	SLR R-P, B	Leaf	Aux. finders	Add-on	X-type	5 lbs. 8 oz.
Mamiya M645 Super	6 × 4.5	Yes	80mm f/2.8	18	SLR	Focal-plane (1 lens: leaf)	Aux. finders	Add-on	X-type	1 lbs. 15 oz.
Pentax 67	6 × 7	No	105mm f/2.4	20	SLR	Focal-plane	Aux. finders	No	X-type	4 lbs. 14 oz.
Pentax 645	6 × 4.5	No 120/220/70mm inserts	75mm f/2.8	12	SLR	Focal-plane	TTL multi-mode	Built-in	X-type	2 lbs. 13 oz.
Rolleiflex SL 66 SE	6 × 6	Yes	80mm f/2.8	14	SLR R-P, B	Focal-plane	TTL multi-mode	No	X-type TTL, OTF	4 lbs. 3 oz.
Rolleiflex 6006 Mod 2	6 × 6	Yes	80mm f/2.8	20	SLR	Leaf	TTL multi-mode	Built-in	X-type TTL, OTF, SCA	4 lbs.
Rolleiflex 6008	6 × 6	Yes	80mm f/2.8	20	SLR	Leaf	TTL multi-mode, auto-bracket, and spot	Built-in	X type TTL, OTF, SCA	4 lbs. 5 oz.

RANGEFINDER MODELS:

MODEL TYPE	FORMAT	ALTERNATIVE FORMATS	STANDARD LENS	NO. OF LENSES AVAILABLE	FOCUS SYSTEM	SHUTTER	METER	DRIVE WINDER	FLASH SYNCH	WEIGHT
Fuji GW690II	6 × 9	No	90mm f/3.5	Fixed	RF	Leaf	Coupled	No	X-type	3 lbs. 3 oz.
Fuji GSW690II	6 × 9	No	65mm f/5.6	Fixed	RF	Leaf	Coupled	No	X-type	3 lbs. 3 oz.
Fuji GW670II	6 × 7	No	90mm f/3.5	Fixed	RF	Leaf	Coupled	No	X-type	3 lbs. 5 oz.
Fuji GS645S	6 × 4.5	No	60mm f/4	Fixed	Uncoupled	Leaf	Coupled	No	X-type	1 lb. 1 oz.
Fuji GS645W	6 × 4.5	No	45mm f/5.6	Fixed	Uncoupled	Leaf	Coupled	No	X-type	1 lb. 1 oz.

PANORAMIC AND ALTERNATIVE FORMATS:

MODEL TYPE	FORMAT	ALTERNATIVE FORMATS	STANDARD LENS	NO. OF LENSES AVAILABLE	FOCUS SYSTEM	SHUTTER	METER	DRIVE WINDER	FLASH SYNCH	WEIGHT
Fuji G617	6 × 17	No	105mm	Fixed	Uncoupled	Leaf	No	No	X-type	5 lbs. 1 oz.
Hasselblad 903 SWC	6 × 6	Yes	38mm f/4.5	Fixed	Uncoupled	Leaf	No	No	X-type	3 lbs.

MODEL TYPE	FORMAT	ALTERNATIVE FORMATS	STANDARD LENS	NO. OF LENSES AVAILABLE	FOCUS SYSTEM	SHUTTER	METER	DRIVE WINDER	FLASH SYNCH	WEIGHT
Hasselblad 380-700-38 & 70 IDAC	6 × 6	No	80mm f/2.8	15	Uncoupled	Leaf	No	Built-in	X-type	N/A
Linhof 617 S panoramic	6 × 17	No	90mm f/5.6	Fixed	Uncoupled	Leaf	No	No	X-type	6 lbs.
Linhof 612PC panoramic	6 × 12	No	65mm f/5.6	2	Uncoupled fixed PC	Leaf	No	No	X-type	4 lbs. 3 oz.
Linhof Technar (modular)	4 × 5	Yes	90mm f/5.6	3	Uncoupled	Leaf	No	No	X-type	N/A
Mamiya 66	6 × 6	No	75mm f/3.5	4	RF	Leaf	Built-in, coupled	No	X-type	2 lbs. 5 oz.
Plaubel 69W Proshift	6 × 9	No	47mm f/5.6	Fixed Shift	Uncoupled PC	Leaf	No	No	X-type	3 lbs. 8 oz.
Sinar Handy (modular)	4 × 5	Yes	90mm f/5.6	6 Shift	Uncoupled	Leaf	N/A	N/A	N/A	N/A
Widelux 1500	6 × 12	No	50mm f/2.8	Fixed	Uncoupled	Slit-scan	No	No	None	4 lbs. 1 oz.

TWIN-LENS-REFELX MODELS:

MODEL TYPE	FORMAT	ALTERNATIVE FORMATS	STANDARD LENS	NO. OF LENSES AVAILABLE	FOCUS SYSTEM	SHUTTER	METER	DRIVE WINDER	FLASH SYNCH	WEIGHT
Rolleiflex 2.8 GX	6 × 6	No	80mm f/2.8	Fixed	TLR	Leaf	Coupled	No	X-type SCA, TTL, OTF	2 lbs. 3 oz
Mamiya C330S	6 × 6	No	80mm f/2.8	7	TLR R-P, B	Leaf	Aux. finders	No	X-type	3 lbs. 5 oz.

LEGENDS:

Unless otherwise stated, all focusing is by helicoid

Aux. = auxilliary

B = bellows

ED = electromagnetic drive

M = manual in all references

N/A = not available

OTF = though-the-lens, off-the-film-plane

PC = perspective control

RF = designates range-finder

R-P = designates rack-and-pinion

SCA = European control system

Shift = some degree of shift capability

TTL = through-the-lens

GLOSSARY OF TERMS

ANGLE OF VIEW. The angle of a scene from which a lens accepts light. The wider the lens, the wider its angle of view; the longer the lens, the narrower the angle of view. Angle of view is generally greater along the horizontal axis of the lens, except with square format.

ACHROMATIC LENS. A lens designed to bring the light reflected by two colors to the same point of focus.

ACUTANCE. A measure of lens performance or of picture quality. In terms of sharpness, it is the transitional boundary between the light and dark areas of an image.

ALBADA FINDER. A special viewfinder that projects frame lines onto the scene, indicating the subject area that will be recorded on film.

APOCHROMATIC LENS. A lens designed to bring the light of three colors to the same point of focus; a highly corrected lens.

BACK FOCUS. The distance between the lens' rear element and the film plane.

BARREL DISTORTION. Straight lines in a scene that are rendered concave by the lens onto the film, thereby producing a barrel-shaped distortion.

BELLOWS. A flexible, light-tight enclosure between the lens plane and the film plane, which, among other things, permits camera adjustments for distortion.

BETWEEN-LENS SHUTTER. See leaf shutter.

CENTER FILTER. A special neutral density (ND) filter that is densest at the center, gradually diminishing in density towards the edge. Designed to compensate for the optical vignetting inherent in many ultra wide-angle lenses, these filters are available in different values.

CHROMATIC ABBERATIONS. Errors that occur in a lens' performance when light rays of different colors aren't equally focused.

COLOR-BALANCE FILTERS. Filtration that adjusts light rays to allow a film to respond according to the color range for which it is specifically designed. For example, daylight color film is balanced for sunlight at noon, and color-balance filters may be used to correct its use with another kind of lighting.

COUPLED RANGEFINDER. An optical system that results in sharp focus when the double or split image in the viewfinder is brought into register.

CURVATURE OF FIELD. A lens' inability to reproduce an image on a flat surface, i.e., the film. Stopping down the lens usually cures this problem by increasing the depth of field.

DEPTH OF FIELD. The area of sharpness surrounding the actual point of focus. Apparent in the final image, depth of field increases as the lens is stopped down and is often manipulated by the choice of lens aperture.

DIOPTER. A unit measuring the power of a lens equal to the reciprocal of its focal length in meters.

ENLARGING LENS. A lens specifically designed for use with an enlarger for making prints from negatives.

EXPOSURE LATITUDE. The extent to which film may be over or underexposed and still produce an acceptably exposed image. Traditionally, slide film has a very narrow latitude; color-negative and black-and-white negative materials are more forgiving.

FILL ILLUMINATION. Supplemental illumination designed to ''fill-in'' or brighten a shadow area.

F-NUMBER. The ratio of the focal length to the aperture, expressing the effectiveness of the aperture in relation to the brightness of the image. The smaller the number, the brighter the image and therefore the shorter the exposure required.

FOCAL LENGTH. The distance from the nodal point to the focal point of a lens. Focal length is related to a lens' size and angle of view.

FOCAL POINT. The position of focus when the light rays entering or leaving the lens are parallel to the axis of the lens.

FOCAL-PLANE SHUTTER. A shutter comprising two blinds or blades situated immediately in front of the camera's film plane. The speed of the shutter is determined by the opening and closing of the blinds, or by the width of the slit formed by the two blinds as they traverse across the film plane.

FOCUS. The point at which light rays arrive at their most compact form. Ideally, this is an exact point.

FOOT CANDLE. A measurable unit of illumination.

GRADUATED FILTER. A filter whose density is deliberately graduated in order to change the exposure across the image area. The filter may be clear at one end, gradually darkening to the other, and can be used to emphasize specific areas of the picture or to smooth out excessive brightness ratios.

HYPERFOCAL POINT. When a lens is focused on infinity, the nearest point to the camera that is acceptably sharp. Generally, depth of field extends halfway between the camera and the hyper-focal point.

INCIDENT-LIGHT READING. A measurement taken by an exposure meter by aiming the diffusion hemisphere of the meter back at the camera from the subject.

INVERTED TELEPHOTO. A lens consisting of a diverging group of elements followed by a converging group so that the back focus of the entire system is greater than the focal length of the entire system.

ISO. A method by which the speed of a film's emulsion is rated, for example: ISO 12, 25, 64, 80, 100, 200, and so on.

LEAF SHUTTER. A shutter situated in a compound lens. It usually comprises several metal or carbon-fiber blades that swing open and closed in a reciprocating manner under the influence of either a spring or a linear electric motor.

MTF CURVES. A set of numbers that specify how a lens will perform by indicating how patterns of light and shadow will reproduce in the image plane.

ND (NEUTRAL DENSITY) FILTER. A filter of specific density but no color influence, usually grayish in tone. Used for restricting the amount of light passing into the lens.

OPEN FLASH. The non-synched firing of a flash system with the shutter in an open or "B" mode.

OTF (OFF-THE-FILM) METERING. The measurement of light by a camera's built-in exposure meter whose sensor looks back at the film plane. The meter "sees" the light as the lens sees it.

PARALLAX ERROR. The distance between the axis of the viewfinder and the taking lens, resulting in different portions of a scene being framed in the viewfinder and in the taking lens. Parallax correction can be effected either by a sliding mask in the viewfinder system or by engraved parallax marks on the viewfinder screen.

PENTAPRISM. A five-sided optical device employed to correct in the viewfinder the laterally reversed image formed by the lens.

POLARIZED LIGHT. Light waves that vibrate in only one direction. Light that reaches the eye or the camera directly is unpolarized, but light reflected off an object becomes polarized if it strikes the object's surface at an angle of between 30 and 40 degrees.

REFLECTED-LIGHT READING. The measurement taken by reading the light reflected off an object. Built-in meters in cameras are reflected-light meters, as are most handheld meters, whether spot or averaging.

SHIFT. A camera or lens' ability to move the lens relative to the film plane. Shift may be up/down/left/right, vertically or horizontally moving the image circle projected by the lens. Having shift capability is especially useful when shooting tall buildings and vertical objects because it allows one to correct for converging lines (see Scheimpflug effect).

SCHEIMPFLUG EFFECT. Moving the lens so that the plane of sharpness is relative to the orientation of the object/subject. This correction technique is useful for bringing several objects on an oblique plane into sharp focus on the film without using excessive depth-of-field.

THYRISTOR. A high-speed electronic switch that controls the duration of the light pulse delivered by an electronic flash. Switching is in milliseconds.

TILT. The ability to tilt the lens forwards or backwards in relation to the film plane.

TTL (THROUGH-THE-LENS) METERING. A measurement by a camera's built-in exposure meter of the light coming either through the taking lens, or, in the case of a twin-lens-reflex camera, through the focusing lens. TTL metering eliminates computations involving lens extensions and filter factors because however the light coming through the taking lens is manipulated is detected and accommodated by the TTL meter.

TELECONVERTER. An optical device used to increase the focal length of the prime lens.

TYPE A COLOR FILM. Color film balanced for artificial lighting other than electronic flash. Type A film usually has a color temperature of approximately 3,400 K.

TYPE B COLOR FILM. Color film similar to Type A film but balanced for an even lower color temperature of 3,200 K.

TYPE D COLOR FILM. Not a real designation, but loosely used to describe color film balanced for mean noon sunlight, 5,600 K.

SLR (SINGLE-LENS-REFLEX) CAMERA. An optical system in a camera that allows the photographer to see what the taking lens is projecting by means of a retractable mirror and a viewfinder projection system.

TLR (TWIN-LENS-REFLEX) CAMERA. An optical system equipped with two lenses of similar focal length: a viewing lens for composing the image, and a taking lens for projecting it onto film.

VIGNETTING. A fall-off of illumination towards the edges of the frame that produces dark areas in the final image; a problem typically found with ultra wide-angle lenses.

INDEX

and transmission roll-off, 118
wide-angle, 34, 39, 41, 56, 57, 58, 65–66, 90, 95, 117, 118
zoom, 56, 66–68
Light
available, 105–9
color temperature of, 104–5
polarization, 120, 122
transmission roll-off, 118
See also Electronic flash
Linhof
hybrid-modular camera, 50
panoramic camera, 43–46, 69

Macro lens, 34, 36, 128–29
Mamiya
rangefinder camera, 37, 38–39
SLR camera, 32–36
TLR camera, 25
Medium-format cameras, 22–53
advantages of, 15–19
in astronomical photography, 131–32
automation, 9, 17, 53
in closeup photography. *See* Closeup photography
defined, 8–9
history of, 10–13
hybrid-modular, 50
instant, 51, 53
panoramic, 21, 43–49, 138–39
photogrammetric, 52, 53
rangefinder, 9, 21, 37–39, 122, 130, 138
rotational scanning, 21, 48–49, 137
selecting, 19–21, 22
shapes of, 19–20, 29
single-lens reflex (SLR), 9, 13, 28–36, 65, 131, 137–38
vs 35 mm, 9, 10, 15
travel cases for, 133
twin-lens reflex (TLR), 24–27, 130–31, 139
wide-angle/wide-field, 39–43
Metering, 17
built-in, 26–27, 36, 96–102, 123
electronic flash, 27, 29, 111, 128
handheld, 102–3
Mirror (catadioptric) lens, 58–59
Motor drive, 9, 17

Multiple-transfer-function (MTF) curves, 55

Neutral-density (ND) center filter, 41, 117–18

Off-the-film (OTF) metering, 27, 29, 111

Panoramic camera, 21, 43–49, 138–39
Parallax correction, 130–31
Parfocal lens, 66
Pentaprism, 21, 29
Pentax SLR camera, 29
Perspective-control (PC) lens, 17, 28, 68–71
Photogrammetric camera, 52, 53
Plaubel wide-angle camera, 41–43, 69
Polarizing filter, 120, 122–23
Polaroid
camera, 51, 53
film, 76, 78–79
film back, 18
Portraits
composing, 92–95
lighting, 108–9, 112–13
Printing, 80
Processing, 79–80

Rangefinder camera, 9, 21, 37–39, 122, 130
Rectangular format, 89–91, 98
Reflected-light meter, 102
Reflex Korelle camera, 13
Reseau plates, 53
Retrofocus wide-angle lens, 65–66
Reversing rings, 29, 129–30
Rolleiflex
slide projector, 80–81
SLR camera, 15, 17, 30, 31, 63, 69, 70, 101, 111, 128, 130
TLR camera, 12, 13, 19, 24–25, 26–27, 63
Rollfilm, invention of, 10, 11
Rotational-scanning panoramic camera, 21, 48–49, 137
Rule of Thirds, 85, 86, 96

SCA system, 27

Scheimpflug effect, 28, 68, 69–70, 71
Shift, 69, 70
Shutters
focal plane, 28, 30, 31
leaf (between-lens), 30, 31, 41, 47
Shutter speed, 17, 64, 65
Sidelighting, 106, 107–8
Single-lens reflex (SLR) camera, 9, 13, 28–36, 65, 131, 137–38
Slave flash, 115
Slide projector, 80–81
Sonnar lens, 44
Space-shuttle photography, 15, 18–19, 31, 47–48, 133
Spot meter, 102
Sunny-sixteen rule, 50, 103, 118
Super Angulon lens, 41, 43, 44, 47, 50, 56, 117, 120
Sylvestry hybrid-modular camera, 50

Teleconverters, 29, 127
Telephoto lens, 19, 33, 34, 57, 58, 63–65, 128–29
Tele Sonnar lens, 15, 17
35mm camera, 9, 10, 15, 17, 47, 61
Through-the-lens (TTL) metering, 27, 28, 29, 36, 101, 111, 123, 128
Tilt, 69–70
Travel, with equipment, 133–35
Tripod, 64, 65
Twin-lens reflex (TLR) camera, 24–27, 130–31, 139

Ultraviolet (UV) filter, 123

Varifocal lens, 66
Velvia film, 76, 80
Vest Pocket Exacta camera, 13
Viewfinder
Albada, 38
optical, 41
Vignetting, 117, 119

Wide-angle lens, 34, 39, 41, 56, 57, 58, 65–66, 90, 95, 117, 118
Wide-angle/wide-field camera, 39–43

Zeiss and Voightlander, 12–13
Zeiss Biogon lens, 39, 41, 56
Zoom lens, 56, 66–68